CHARLES GATEWOOD

CHARLES GATEWOOD
A RE/Search Pocketbook
©2015 RE/Search Publications
ISBN 978-1889307-42-8

PUBLISHERS/EDITORS: V. Vale, Marian Wallace
COVER & BOOK DESIGN: Marian Wallace
INTERVIEWS: V. Vale
RE/Search copy editors, staff & consultants:

Julia Helaine
Kelsey Westphal
Andrew Bishop
Emily Dezurick-Badran
Robert Collison
Meg de Recat
Gail Takamine

Gloria Kwan
Karlo Pastella
Joe Donohoe
Chase Harris
Beth Cooper
Judy Sitz

*Please check our website or contact us to find
out about our full line of books and media.*

RE/Search Publications
20 Romolo Place #B
San Francisco, CA 94133
(415) 362-1465
info@researchpubs.com
www.researchpubs.com

TABLE OF CONTENTS

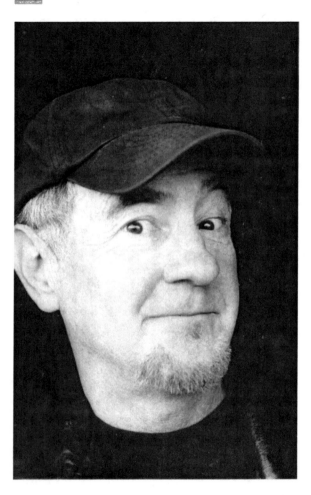

INTRODUCTION by V. Vale

How many amazing, original, hard-working and deserving photographers (and indeed, artists) have yet to become world-famous, household names?

In 1975 I was a William Burroughs fanatic, searching bookstores (pre-Internet) for anything and everything containing his words, including magazines, little magazines, literary magazines and books printed overseas. At a bookstore in San Francisco's The Cannery (the long-gone Upstart Crow), on the recent arrivals table was a new photography book titled *Sidetripping,* with text by Burroughs and photographs by Charles Gatewood. Immediately, this became my favorite photography book exploring the boundaries of "social acceptability".

When Punk Rock was inventing itself in 1977, I began publishing *Search & Destroy,* funded by Allen Ginsberg and Lawrence Ferlinghetti and published at City Lights Bookstore. Quickly more contributors came aboard as the movement gained critical mass, including a young man who renamed himself Lee Paris ("Punks" were encouraged to take on new "identities"). Lee Paris interviewed Helen Wheels, whose photographs were supplied by—Charles Gatewood! Since 1977, Charles has been a huge supporter of my publishing, generously providing photos whenever possible. We at RE/Search think: *Charles Gatewood Is a Pioneer of Avant-garde Photography...* whose work will continue to illuminate, stimulate, and inspire.

<div align="right">—V. Vale, RE/Search founder</div>

A Visit with Charles

■ Vale: Didn't you just sell your archive?

■ Charles Gatewood: A university library gave me money for my archive: enough to live on for the rest of my life. They let me keep my big prints, and more. I'm making a lot of collages now; I'm aiming not to be one of those old guys that falls asleep in front of the TV.

I've been doing what I do for over fifty years, so it took over five years to database everything by hand—two copies (and then market and sell it). It was actually great fun because I got to look back over fifty years of photography—from the earliest Mardi Gras, New York, and *Sidetripping* work, to the Woodstock years up through the California work: the *Modern Primitives* Body Art movement and other counter-cultural activity here.

■ V: Let's focus on the physicality of the archive: what got taken away? Twenty boxes of

negatives, contact sheets, prints?

■ CG: They took many boxes: almost all the vintage silver prints, 8x10s, 11x14s and all the negatives and contact sheets I ever made: a hundred thousand; maybe a little less, maybe a little more—almost all black-and-white. When I came to California I started shooting some color, but most of my "good" stuff—the early and middle work—is black-and-white. When I started out, that was what art photographers *did*. You could do it yourself in your basement; you didn't have to have a special laboratory—

▮ V: The original D-I-Y: you don't have to leave home. You stay home and do the work and suddenly you have a beautiful black-and-white print that'll last a thousand years—

■ CG: Exactly, and the cost was affordable; low. Ever since I was a little kid I wanted to be an artist and could never find my "thing" 'til in college grad school I found photography, and I'm still going down that same road.

Actually, I'm doing work now that's different; I'm branching out and trying *collage*. But the Archive wasn't interested in my collages, so I got to keep most of 'em, which is terrific; it's like a *win–win*.

▮ V: So what else was in these boxes?

■ CG: Work prints, years of correspondence

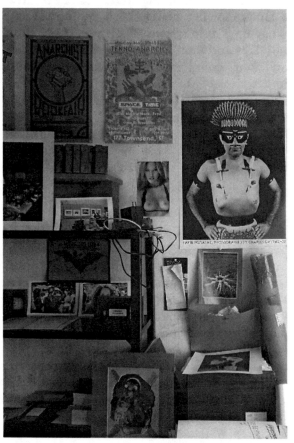

Charles Gatewood's office

with other artists, a few books… They brought a laptop so they could check and see exactly what they didn't have. They were here three full days and then the movers came (a director and four strong guys) and it took four hours to get most of the boxes down three flights of stairs.

■ V: But who *packed* the boxes?

■ CG: They have a team that does that. One guy chose exactly what they wanted and two other guys put it into boxes. I advised them: "You've got to take Marco Vassi's first book." They'd never heard of him, but they took it—so I helped, too.

There used to be over a hundred yellow legal pads here in a pile; I do all my "verbal sketching" on them. While I'm eating breakfast or listening to music, if I have a thought or see something in the *New York Times*, I'll write it down. I thought every statement was brilliant—but maybe only every tenth one is. Now they're in some air-conditioned storeroom—I hope.

Now they *didn't* take the big silkscreens; the director said, "We don't have space for them." Vintage silver prints they want; they're not making any more of them.

■ Marian Wallace: They're not making the paper as good anymore, and the chemicals are

different.

■ CG: I feel fortunate to have come into photography during that period when you could Do-It-Yourself: black-and-white. You could experiment; it was so new, like: "Wow—how did you DO that?!" The guy who taught me photography in college, George W. Gardner—

▌ V: How much older was he?

■ CG: A year or two. He had a brilliant print of two white guys in a black sports car, and two black guys walking along a sidewalk, and they were *looking* at each other. The composition was absolutely dead on; it was during the Civil Rights period, and I thought, "Ohmigod... *That's* what I want to do!"

The J-school (journalism school) at the University of Missouri was very famous in the publishing world and the academic journalism world; after they graduated, graduates would work at all the big magazines. At the age of 23, George Gardner had already had two covers of *Life* magazine. When I went to his house the first time there was a contact sheet of photos of his little brother drinking a glass of milk: every shot was the same shot, but just a *little* different. And **I went, "Ah... that's how they do it! They don't just take one or two pictures—they take *a lot!*"** So once you under-

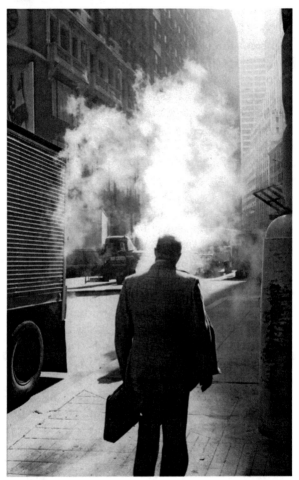

from *Wall Street*

stand "how it works," it all becomes easier.

▌ V: How would he pick the "best" of the ten or twenty—

■ CG: He was kinda like a gruff old farmer: "Well, *this* one makes it. Nope, that *doesn't* make it." We didn't talk much about the "philosophy of photography." He put his work on the table, and his best is as good as anyone's.

▌ V: But you didn't have any "discussions"? Like, as a kid, I remember reading about "the decisive moment," which is from—

■ CG: Henri Cartier-Bresson—I know my photographic history! **The kind of photography I do is documentary photo-journalism with a *twist*.** But a lot of my work is "Ohmigod— *you can't DO that!*" I've been ostracized by the art world for my subject matter; shows cancelled, etc. But I have a degree in anthropology as an explorer of contemporary society, trying to bring back the same kinds of information an anthropologist would bring back from some foreign country.

▌ V: Let's hear more about George Gardner—

■ CG: He was a magazine photographer, a book photographer; **he did black-and-white photo-journalism that was really good and that often had something surprising—**

▌ V: Humor!

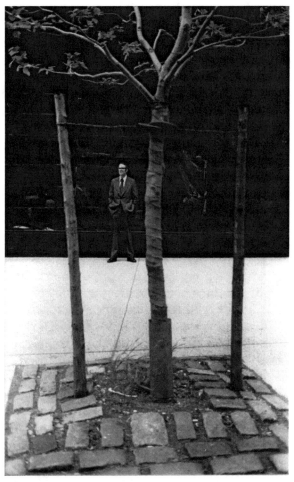

from *Wall Street*

■ CG: Yes, and not just humor, but... I lived in Sweden in '64, '65 and '66. "They" were trying to send me to Vietnam but I wanted to live in Europe for awhile and learn photography.

▌ V: Did Gardner encourage you to leave so you wouldn't get drafted?

■ CG: No, he was in the army for a while.

▌ V: What did Gardner do for you?

■ CG: He showed me the *vision* that I'd been looking for: *The Family of Man* book, for example—that kind of work. Humanistic photojournalism.

▌ V: There wasn't that much photography like that out there then—

■ CG: There *was*, but it was like a club. There were in that group maybe fifty or a hundred really, really good photographers around the world, like Robert Capa and the big names everybody knows. **There were maybe another fifty or a hundred really good photographers that didn't get famous—**

▌ V: There are *many* people like that; thousands—

■ CG: There are.

▌ V: How many hours did you spend with Gardner: Hundreds? Thousands?

■ CG: We were best friends and still are; over fifty years. But we *really* got together after he

moved to New York. He'd been living in his cousin's back room in Delaware because it was cheap; he was a purist and living there was inexpensive. **It's not easy to make your living as a photographer.**

▌ V: Wait; how long were you with him in Missouri?

■ CG: A few months in '64; we took a class together as anthropology students.

▌ V: But he'd already gotten two covers on *Life* magazine by then?

■ CG: When he was a student he supported himself by selling pictures to the yearbook and different magazines. He's a *natural* and was a professional early on. He was also a good marketer; he knew how to go around and shmooze the editors and show them his work.

▌ V: Did he share his connections with you?

■ CG: Yes. And as I said, the University of Missouri J-School was the spawning ground for a lot of the famous photographers of that period, like Cliff Edom.

In 1970 George bought a farm across the river from Woodstock about a hundred miles from New York City. It cost $24,000 for an old house, a barn, five acres of land and a trout stream! He built a darkroom and he still lives there with a barn full of vintage silver prints.

A few years ago he had a show in New York and sold sixty- or seventy-thousand dollars' worth of prints at Debby Bell's gallery. So he had one big show and published one big book titled *America Illustrated*. I think it was limited to 200 copies; oversized, on heavy paper. It's a beautiful book, hard to find.

▌ V: Hardback in a slipcase. So you were only with him a few months in 1964?

■ CG: Yes, but it turned into a lifelong friendship. We'd go to New Orleans every year for a week to shoot Mardi Gras. We did that for nine years in a row—

▌ V: You mean when you shot *Sidetripping*, right next to you was George Gardner?

■ CG: Not only that, we were sleeping in the back of his old beat-up Peugeot and washing up at the bus station.

▌ V: What was your camera and what film did you use?

■ CG: M-2 Leicas, Tri-X, Pan-X. 35mm lens mostly; 21mm I liked also—really wide.

▌ V: I thought Cartier-Bresson used mostly 28mm—

■ CG: Yeah… 35mm was popular with a lot of guys because you could do a lot with it—

▌ V: —without the distortion of wide-angle—

■ CG: Well, *some* distortion is okay. **You know**

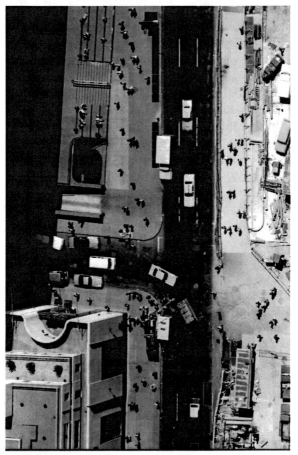

from *Wall Street*

the picture in *Sidetripping* of a black guy with a huge dollar sign? That's with a 21mm lens a foot away from his face. That picture would never have the same look or impact or feeling any other way. It was a certain distance and a certain optic.

▌ V: You didn't have zoom lenses in those days?

■ CG: Well, I did, but they were heavy. If you were a photo-journalist on the street, it was enough to have three or four cameras around your neck. Usually I had a big Pentax with a long lens on it—

▌ V: You mean a 6x7 Pentax?

■ CG: No, a 35mm with a long lens. That picture of the cop spitting into a wastebasket was taken with that because they wouldn't let us near the courthouse—they made us all stand across the street where we couldn't cause any trouble.

▌ V: Wait a minute— you walked around with two or three cameras hanging from you—

■ CG: —or more; later I added video.

▌ V: What are these cameras?

■ CG: Leica M-2, Leica M-2, Pentax... Later I had a pocket camera too, something small—

▌ V: The Leicas were the first small cameras—

■ CG: Well... Leicas were *heavy*. You ever pick up an old Leica? I just gave my last Leica to

David Rinehart the other day…

▮ V: Okay, so you would actually physically walk around with four cameras?

■ CG: Plus all the film and whatever else you walk around with. **We were young, strong, and determined.**

▮ V: You didn't have a photographer's vest, or a huge backpack?

■ CG: Uh, a little of everything. Mostly we had one camera on each shoulder, and one camera around the neck.

▮ V: That's three.

■ CG: Okay. It was all so *heavy*. Today's cameras are so light. It's hard to remember those big clunkers…

▮ V: We're talking about you and George walking in New Orleans before *Sidetripping* came out. What was your routine? Did you get up at 6 in the morning and shoot 'til midnight?

■ CG: You'd get up in the middle of the morning and have a nice New Orleans breakfast, then hit the streets. Basically stay in the streets all day, go to the "right" parades… At night the "gay" end of the French Quarter was always fun. Bourbon Street near Canal Street is for straight people—shoppers. But way down Bourbon near the Olde Absinthe House—that's the gay part.

■ V: How did you know that? You weren't gay—
■ CG: You'd learn it by going! At the gay end of the street, at a certain time of year (this was fifty years ago) gays could be beaten or killed or robbed or—it was really dangerous down there. George and I called this "going into the field"—anthropology work. But we *didn't* do much field work at the *university*. I did graduate work but the closest I came to field work was I did a thirty-page paper on leaf-rakers—men on campus raking leaves: how they did it, where they did it, why they did it, who made the tools they did it with... **I went in with an attitude: that I was going to a *different country*.**

I learned that each group has its own set of values, its own codes... I've always been stubborn about my dress: "I'm an old beatnik—I don't do 'codes'!" But an outlaw biker laughed at me one day because I was wearing loafers. I had trouble at Burning Man because I was wearing white instead of black—but I had joined a camp which this German Satanist dominated...

■ V: Going back to George Gardner; what did you DO those four months in Missouri?
■ CG: We were surrounded by three college dorms full of young women, really close. I used to go on the roof at night and drink beer and

watch the girls. I told George, "Come over and bring your camera; this is the greatest show in town!" He brought the camera but *didn't* stay long enough to photograph the girls; that wasn't really his "thing." But anyway, that's how we came to spend time together.

■ V: And later you went to Mardi Gras nine times with George Gardner?

■ CG: Yes. That became our bonding. If it was February, it was Mardi Gras time. If it was summer, it was something else. If it was spring, a lot of times I'd go to Daytona Beach Bike Week and shoot the bikers—the whole look: the bikes, the dress, the posturing... Thousands of outlaw bikers come every year to the same town—the sound, the noise, is unbelievable.

Once, George Gardner and I thought it would be fun to go to an motorcycle rally in upstate New York. But when we got there, it was a bunch of outlaw bikers; there were no police; they were drinking beer... It was on a dirt road going back into the woods. We looked at each other and turned around and left. Because we were outsiders going into an insider event—with no security. Now I don't mind much if they *laugh* at me, but I don't want my head chopped off!

But early on and most importantly, **we**

would sit and look at *The Family of Man* book, which really changed my thinking.

▌ V: There was a sequel to it—

■ CG: I have a picture in that one: *The Family of Woman.*

I spent a lot of time studying the work in George's portfolio: 11x14" gorgeous silver prints. It was clear he was a genius.

▌ V: What was the content?

■ CG: He's a white Midwesterner; actually, he grew up in Pennsylvania. The content was Wasp-y, but he was also very concerned with Civil Rights. He photographed the Martin Luther King march in D.C. in '63; got great pictures of that. He was an outspoken critic of racism; once I saw him in a bar almost get into a fight with a guy who'd said the word "nigger"—he put him up against the wall. He had very strong beliefs about human rights.

▌ V: Was he like Bill Owens, shooting middle-class white people in their suburban homes?

■ CG: No, he covered the waterfront. He did Bill Owens, but he also did ghetto interiors. Cornell and Robert Capa used the term "concerned photographer" and he was one of the "concerned photographers" from that school; you can google that topic…

▌ V: Were they related—Cornell and Robert?

■ CG: Yes. I worked with Cornell at the ICP (International Center of Photography, in New York). I helped him build it. He twisted some corporate arms and got a lot of money back when New York was affordable, and he bought the old Audobon House on 5th Avenue and 92nd Street—

▌V: You mean the "bird painter"—

■ CG: Yes. I taught there at the ICP in the early Seventies. It was considered one of the best photography schools in the world.

▌V: So what did George Gardner do that was most illuminating to you?

■ CG: His *attitude.* That one person could do brilliant work on his own, *without sponsorship.* **He rode his motorcycle all over Mexico photographing pyramids and Mexican archaeology sites on his own dime, because that's what he wanted to do. *Then* he found a market and sold them.** He was just back from that trip when I first met him. Then he was on his way to D.C. for the Martin Luther King march, and I thought, **"This is an interesting lifestyle: he's making money, documenting history, doing his art."** And I wanted to be like George!

▌V: You didn't imitate him and get a motorcycle, did you?

■ CG: Yes, I did! I got a little Honda to drive around Europe in 1964, because I was tired of hitchhiking. I wasn't a biker, but I was doing my own thing my own way, like George, on my own dime.

▌V: How big was the Honda?

■ CG: I'm too embarrassed to tell you! I think it was a 49cc.

▌V: What else did you learn from George?

■ CG: To "do your own thing"—to "follow your bliss," and not get caught up in—well, working in an ivy-covered building in a university town can be a very nice life—but that's not the life I chose.

▌V: So how did you get a Leica camera in Missouri?

■ CG: I bought it later on in Paris, in 1964.

▌V: You went to Paris—how did that happen?

■ CG: I did a year of graduate study at the University of Missouri (I had graduated in '63). Then in the summer of '64 I wanted to go *live* in Europe. You didn't have to have money in those days—*Europe on Five Dollars a Day* was a famous book then; everybody had it. Money wasn't important; you could hitchhike and sleep in fields.

▌V: How did you get there? You had to have money for a plane ticket.

■ CG: I worked on ships.

▍V: You worked on ships?

■ CG: More than once. (**If you really focus on something, you can make it happen**.) Kerouac and the Beats made working on a ship sound romantic and fun. But it was boring! Your fellow sailors were mostly dumb farm guys. And the noise—working in the engine room of a couple Norwegian ships totally ruined my ears. (Then I became a rock'n'roll photographer in New York and had the rest of my hearing destroyed!) Working on a ship is hard, hot and dangerous—and I think the pay was forty dollars a month.

▍V: Wait a minute: you're in Missouri, and then you go to New York—where'd you stay in New York City?

■ CG: I stayed in a hostel for a dollar a night, and if you didn't have the dollar you could sweep the floors. I found out that the unions were so tight you couldn't get work on any lines but Norwegian—they had so many ships. I went to the Scandinavian shipping office in Brooklyn and they told me to "Get lost!" I went to another one; they told me: "Get lost!" I talked to a couple of sailors and they said, "You might get something on a Norwegian ship, but it's really hard. You should probably go back to

Missouri."

I had met a "rich" girl at Stevens College, a

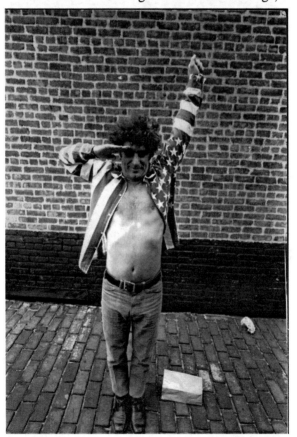

Abbie Hoffman

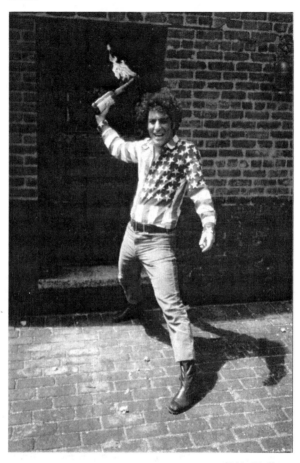

Abbie Hoffman

private school in Columbia, Missouri, and con-
tacted her. She invited me from my dollar-a-
night hostel to dinner at her Upper East Side
mansion. They served food I had never heard
of; it was a whole different world. Then the
father said, "Gatewood, what's going on with
you?" I said, "Well, I had this dream I was go-
ing to travel around the world, go to Sweden,
and check out this 'enlightened socialism' I've
been hearing about. Maybe I'll live over there.
America's trying to send me to [the Vietnam]
war, and I'm not too crazy about that idea."
And he said [avuncular tone], "How are you
going, my boy—are you taking a cruise liner?"
I said, "I'm trying to get a job on a ship, sir.
But nobody will hire me." He said, "Oh, don't
worry" (he was a partner in a Wall Street law
firm) and he made one phone call and got me a
job!

▌ V: That's what I call "luck." **The Surrealists
said, "Your desires create your universe."**
A rich person made one phone call, you got the
job, you worked hard on a boat for ten days—

■ CG: I was on the first ship for about ten *weeks*.
It went to Argentina, Brazil, Venezuela. Twice
in Brazil, twice in Argentina, once in Venezue-
la. Then we went to Amsterdam—I got a week
off in Amsterdam because they were cleaning

the ship. I had been treated as a "special friend of the Captain."

▮ V: Wait a minute—you didn't photograph Argentina and Brazil because you didn't have a camera yet?

■ CG: Right.

▮ V: How did you get the money for the Leica?

■ CG: I worked as a busboy for three years in college and I saved up money. My father left me a little money when he died.

▮ V: How much did the Leica cost?

■ CG: $350.00. I went to a camera store. I knew to get a *Leica* from George Gardner, but he didn't tell me which lens to get. So **I got a cheaper lens than I should have gotten—**

▮ V: Ah, that's a lesson there!

■ CG: It was a Leica lens, but it was a 2.8 instead of a 2.0. The optics weren't quite as fast. Then I headed to Sweden to attend a special school called the Wennergren Center for International Students in the Social Sciences. It was the most boring—

▮ V: They didn't teach you how to use your camera?

■ CG: Not, it was sociology and psychology—not photography. It was intellectuals talking about ideas and theories, while outside the Sixties were starting to explode! I found out I was

not made to be an academic.

▮ V: Did you know Swedish?

◼ CG: No, but the classes were taught in English, and most Swedes know some English. And in this school, all the classes were taught in English because it was an international graduate school for English-speaking students. However, after about two months, **I wrote letters to all the photographers in town asking for an internship**—

▮ V: That word didn't exist back then—

◼ CG: Or an *apprenticeship.* I said, "I've just got my Leica. Photography is my life, but I've never even developed a roll of film, let alone printed. I need to learn the basics. In exchange I'll help you with whatever you need." And one person wrote me back; he and four other photographers had a group called Visum and they needed a go-fer, a helper. Swedes are pretty famous for the quality of their work, and their quality was quite good for black-and-white documentary photography. They were "Concerned Photographers." **They taught me how to develop film** *just right***, how to make a contact sheet, how to make sharper prints.** They showed me how to make all kinds of *different* work: you can do *this*, or you can do *that*. It's one thing to look at *The Family of Man* and go,

"I can do that," but it's another thing to *do* it.

▍V: Were you trying to do your own *Family of Man* book?

■ CG: You could say that!

▍V: Did you ever consciously imitate any of the photos in *Family of Man?*

■ CG: More *unconsciously*. When you look through books like that, the *composition* really hits you hard—**every one of the pictures in Family of Man is really, really well-composed—put together very well, with a special kind of *magic.*** If you look at enough photography books, some of that seeps into your *seeing*—hopefully.

▍V: Kamera Zie told me, "**Photography is subtraction; Painting is addition**." Of course, if all you have is a 21mm wide-angle lens, then you can take a picture and then *crop* it. Did you do much of that?

■ CG: Well, yes and no. I was a "purist" when I started out: your picture should be full frame and not copy anybody else too much. It should be your own vision, unique, and you do it your own way.

▍V: At that time, wasn't Tri-X film manufactured in—

■ CG: Rochester, New York. But it wasn't expensive to buy in Sweden; compared to today,

everything (chemicals, paper) was cheap.

▌ V: Where did you first live in Sweden?

■ CG: I lived in a rented room; there's a photo of me in the bathtub there. My room cost thirty dollars a month. **As long as I stayed in school, my father's trust fund would send me two hundred (or two hundred-and-fifty) a month—just enough to get by.** Also, the photographers would tip me at the apprentice job.

I found the room through the school. Most of the time I ate in cheap "grill" bars or coffee-houses where transients and down-and-out people went to get a cup of coffee and eat. After two months I dropped out of school. Then I spent a lot of time at libraries looking at photography books, art books, studying the composition, the history of art, researching and looking. I spent a lot of time shooting on the street with my new Leica, fall of 1964–1965.

▌ V: What did you shoot "in the street"?

■ CG: Disaffected youth in coffee-houses, pretty Swedish girls with long blonde hair down to here [gestures waist-level] who had never seen a Leica before. People, mostly. The first anti-Vietnam-War protests were starting. There were also *pro*-War protests; demonstrations in *favor* of the Vietnam War, with people carrying signs

and yelling. The first "hippies" started appearing, hitchhiking, carrying their sleeping bags...

▮ V: But what was the weather like? I thought it was terribly cold in Sweden—

◼ CG: It's awful; winters are freezing; it's dark. When spring finally comes, people come out like zombies and just stare up at this pale sun. It's rough. (I always spent the summers down in the South of Europe.)

I started out as a natural-light photographer, but I knew how to use a flash. There's an early photo of me with what looks like a bolt of electricity going across my face, like static electricity—that was my first self-portrait. But I was still learning my "chops"... taking pictures in public of people—nothing too radical; I think protesters and Swedish girls were *it*.

▮ V: But **you were getting practice on the street, looking for that "decisive moment," or "perfect framing"**—

◼ CG: I used to shoot in jazz clubs with natural light. A lot of African-American jazz musicians would go to Sweden because Swedes love jazz. There was a circuit; there were three or four jazz clubs in Stockholm and The Golden Circle was the best. I wrangled a press card and shot a lot of my first music pictures there. After I got back from my second summer [1965] traveling

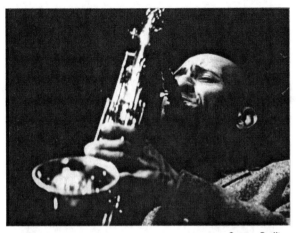

Sonny Rollins

around, I got a job at a news agency.

Swedes were kinda shy but nice and friendly. I never had any problems there when I was photographing, but I wasn't photographing very weird "stuff" then. I was just learning composition...

■ V: But did you know those "rules of photography" like "pay attention to shadows" or "look for shadows"—

■ CG: I learned a lot of that as I went along. **Once you take a picture, make a print and look at it for awhile, you go, "Oh, this would have been better if I had done this,**

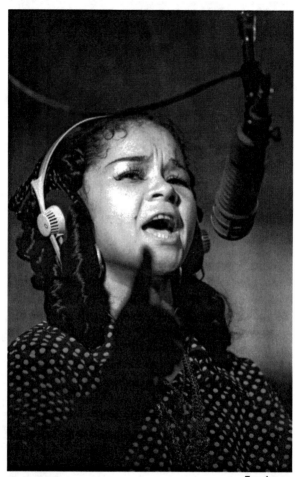

Etta James

and this, and this..." **You learn by doing**, and I'm *still* learning by doing! I'm learning how to make collages now, and you can't "think" it, you gotta work at the table and move things around until: "Wow—that's IT!"

I had a pretty solid education in Surrealism, too—I know about collages. In college, besides anthropology, my other major was Art History. I took eighteen or twenty different classes in art history; **I looked at every art book and art magazine I could find.** I learned from Surrealism that it's really cool to put *this* together with that, and make *that*. Every time I make a good collage I just start laughing; I feel really stupid because I didn't "see" it yesterday. I had the same pieces of paper [pictorial elements] but they didn't go together the same way. Now that I'm doing more collage, I'm encouraging that kind of "accidental-on-purpose" work.

▎V: **Photography has been compared to hunting; it's instinctual and super-fast, partly-animal reflexes—you don't have** *time* **to think** if you're doing street photography. **You see something weird and** *click!* That's the nice thing about the Leica—it's so fast. My digital camera takes at least two seconds, and by then the subject has moved on...

So... you toughed out nine months in Swe-

den and then—

■ CG: I hit the road again. It was Spring 1965 and the sun had just come out.

▌V: Did you just stick your thumb out on the nearest highway?

■ CG: Yep.

▌V: You didn't take buses or trains?

■ CG: Rarely.

▌V: What was your first ride?

■ CG: A guy picked me up in a truck. He was distributing the first porn movies, and he had a whole truckload of *Love 1* and *Love 2.* He was taking these around to the first Super-8mm film stores. Sometimes I'd get five or ten rides a day.

I don't think I've explained myself right. I took that first Norwegian ship in the Summer of *1964.* We hit Amsterdam where I got a week off. That was my first taste of Europe. I stayed in cheap hotels—three dollars a night. You could buy a nice sweater for four or five dollars.

I traveled around Europe on my cheap Honda 49cc. In Paris I got my first Leica camera.

After the school year in Sweden, I traveled around Europe during the summer of *1965.* Then I came *back* to Stockholm and got a job with a *real* photography production place— that was the beginning of my *second* school year. It was called Abe Text and Pictures (text

hitchhiking in Europe

und bilder); it was a news agency that syndicat-
ed work all over—pictures would come in from
Paris and they would syndicate them to all the
Swedish newspapers. They had their own team

Boz Scaggs

of photographers; I ran into a Swedish friend the other day who said it's still there. (It was Carl Abrahamson; he's Swedish but lives in Copenhagen, Denmark.)

So they hired me as a darkroom worker and I got a press pass. I really hit my stride in '65 to '66. I spent days in the darkroom and nights in the jazz clubs. I shot portraits, I shot protests, I met more people, I was more confident, my photography was getting better.

In Stockholm I met Boz Scaggs. He was just starting out, singing in cafes. In the jazz clubs I shot Ornette Coleman, Sonny Rollins, Don Cherry... It was a good way for me to learn my chops, get pictures that I could sell and show, and get more experience. In 1965 I had worked for Visum and they had let me check out equipment so I could learn; in exchange they could use any pictures I took. I hate to tell the story, but I got *this* close to Martin Luther King; I shook his hand; I had my camera In my hand and I'm telling him how I'm an American and I'm an expatriate and all of a sudden somebody grabs him and pulls him away and he's gone and [whispers] *I didn't get a picture.*

▌ V: I guess the lesson here is: Get the picture immediately!

■ CG: **I learned that pretty fast. Get in**

their face right away and Don't Ask—Just Get It! And this was my *hero;* I worshipped Martin Luther King. I was a liberal-radical.

▎V: How did you get to be that way?

■ CG: Starting in the fifties, with the Beatniks, James Dean, the whole fifties anti-establishment "thing'"—I was fascinated with that. It was forbidden, it was sexy.

▎V: And maybe you were influenced by the whole folk music protest movement—

■ CG: I was in college then. My New York friend whose dad got me that Norwegian ship job—she was a big folkie fan and she had played all the records for me—

▎V: And the records then were Bob Dylan, Pete Seeger; Peter, Paul and Mary; Dave van Ronk, Tom Paxton, Joan Baez—

■ CG: I photographed her in Sweden in '66. She and Bob Dylan had a romance and he took her on his Stockholm tour. But they were breaking up, so it was kind of weird—

▎V: She was way more famous than him earlier, when she took *him* on a tour.

■ CG: It was weird, because he took her to the press conference, and he was sneering at the press. She sang three songs for the press, and she didn't appear at the concert that night at all. She wasn't really on the bill; she was just

Bob Dylan

Joan Baez

along on the trip.

▌V: I think her star was starting to descend in 1966—

■ CG: But Dylan's was certainly rising. There's a place in New York called Rock, Paper, Photo and they sold a Dylan print of mine from that period. They make big beautiful digital enlargements of famous rock'n'roll photos. People order one online; they send it to me by UPS to sign; I return it by UPS and… It's nice, because I don't have to make the print.

▌V: Tell me about that *second* summer of 1965 trip in Europe—

■ CG: A bunch of friends piled into a VW in Paris and went all over Holland, Italy, Spain, Greece and Turkey and—**can you imagine five people in a VW?!** And it was cheap. "You want to go to Germany next week? You don't have any money? It doesn't matter; just hitchhike!" I went to a dozen of the big towns and a lot of the small towns in Germany.

In April 1966 I got drafted, and I also took my first LSD. July 4th I went back to America and reported to the draft board. I came home with a beard and a Swedish accent, and there were some things on my medical form that looked weird to the doctors. I think overall they just looked at me and said, "Get this one out of

here!"

In Stockholm a friend in Zurich had sent me a sheet of blotter acid, ruled on blotter paper by hand—no marks. This was some of the first LSD in Europe. I had just come home from work, hadn't eaten anything, and there was this package from my friend Hallsey. So I tore off a little square and ate it. I filled a whole notebook with my journey; that first "trip." I saw the most amazing things I had ever seen.

My next big dream was to go to Rochester Institute of Technology and get a Masters Degree in Fine Arts Photography—you know, *do it right*. But it turned out that unless you were from in-state, it was really expensive. **I wanted to be a photographer, or teacher—be *somebody* in that world.** I showed my prints to some students at R.I.T. who were sitting in the hallway between classes: "I just got here from out-of-town, and wonder if you'd look at my work?" The students were blown away: "This is incredible! Why don't you just go to New York City and DO IT!"

That hadn't been in the game plan, but I moved to New York, got a fifty-dollar-a-month apartment on the Lower East Side, 224 East 7th St at the corner of Avenue C.

▌ V: That was a *bad* neighborhood then—

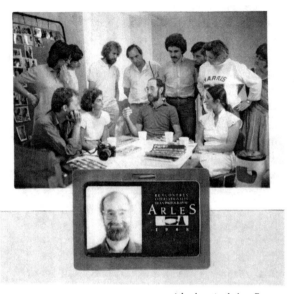

with class in Arles, France

■ CG: The rent was fifty-two dollars a month; bathtub in the kitchen. So all of a sudden I was in New York; I had my chops, I was honing my skills. I took a photo of a girl with a bag on her head in that three-room apartment.

▌ V: Who gave you your first N.Y.C. job?

■ CG: Well, that's embarrassing, too. I got my apartment, I looked in the newspaper and saw a job for a photographic printer. The guy

looks at me (New York attitude) and says, "I don't think so." "Come on, give me a chance," I said. He fired me after three hours of work: one print was too dark, one had a tear in the corner... He just didn't like me; "I wasn't good enough for New York." I remember going out to sit on a park bench... Anyway, I went to an employment agency and got a job as a second photographibc assistant in a big studio for seventy-five dollars a week—you could live pretty well on that. And **I learned all kinds of *new* darkroom tricks and studio lighting—I learned a *lot*.** Jackie Smith Studio, 8 East 12ᵗʰ Street, just off Fifth Avenue.

I learned *real* "stuff." Then a guy I'd worked with offered to share his loft with me. So I had a huge loft for a hundred dollars a month... I'd come from this ghetto nightmare slum to Fifth Avenue in less than a year! After that, the rest is history: I sold work to magazines, textbooks, I did *Sidetripping* in 1975 and that book changed my life.

▮ V: Let's go back to your time with John Willett, the New Yorker you met in Stockholm. You traveled with him across North Africa—was it summer of 1966? Where are those pictures?

■ CG: Those photos weren't published; they're different from my other work..

■ V: Whose idea was it to go through North Africa?

■ CG: Both of us. We both loved adventure-travel. He was a writer. He was wealthy, but he would vary between a really wealthy trip and a really poor trip. After we did our *North Africa On Two Dollars A Day* trip, he flew to New York, bought a Rolls Royce, and did a *North America On Two Hundred Dollars A Day* trip!

■ V: So you started out in Sweden—

■ CG: **We hitchhiked in Scandinavia way up north above the Arctic Circle, where they don't even have roads. We did extreme travel where there are no people.** Hitchhiking across the North African desert: Libya, where you could be shot because they don't like the way you look. Some of what we did was quite dangerous, but all done in the "Spirit of Adventure."

■ V: You took the ferry from Spain to Tangier—

■ CG: Exactly. This was one of my favorite trips because of Marrakech. We went through Morocco, Algeria, Tunisia, Libya, Egypt—

■ V: Did you photograph the pyramids and statues of Egypt?

■ CG: I've been there four times. I took pictures but they're not very good. There's a couple good shots in there; a couple. I almost

got stuck there. John and I had had a fight—we weren't getting along, and he went south up the Nile, and here I am in Alexandria with very little money and there were wars going on. Ships were not on their regular schedules, so it took ten days to get out of there. I arrived back in New York with twelve dollars in my pocket.

▮ V: But didn't you make money on the ship?

■ CG: No, this was a "get-on-and-pay." It was a Russian ship; I remember playing chess on deck with all these Russian guys.

▮ V: Where did you stay in Tangier?

■ CG: Tangier is magical; there's more magic in Tangier than... Burroughs is your source for that—the whole Burroughs gang. A lot of gay men have houses there. The first night in Casablanca John Willett and I stayed in a whorehouse and he got the crabs—we didn't know that a red light out in front meant what it meant! I also met other friends along the way: part of the Paris gang, young people from Missouri...

▮ V: How did you keep in touch with everybody, before the Internet?

■ CG: We wrote letters and postcards to each other.

▮ V: In Tangier, was it easy to get your film developed and contact sheets made?

■ CG: No, it was like the Middle Ages back then, and it probably still is. Some of my Moroccan work is pretty good, and Egypt as well. It's in my archive.

▮ V: So John Willett got crabs—

■ CG: That was funny. We were hitchhiking out of town, and he kept scratching himself: "What's going on here?" *That's* budget travel! We went through Algeria and then, Tunisia was *nice*: lots of little picturesque villages that looked like they were out of a travel magazine. The whole North African coast is right along the ocean. After hitchhiking all day we'd take off our clothes and go jump in the ocean, then sleep in the Roman ruins... anywhere.

▮ V: Who gave you rides?

■ CG: Locals. They didn't speak English. They thought we were very peculiar. We'd be out there hitchhiking and school would let out and forty screaming schoolkids would come out and go, "Yea! Whatever you're doing, keep doing it—it's great!" They would surround us, so nobody could see us and give us a ride. The kids were fascinated by us. But I tell you, **we could have been killed, or robbed, sleeping in the woods in Algeria. We did get stopped once by the police and searched**, because they didn't know *what* we were doing there.

W.S. Burroughs

and Alexandria.

▮ V: Do you have any photos handy from that trip?

■ CG: There's a horizontal of a woman protesting; her hand is up and there's a mural behind her of these planes shooting each other out of the sky. Nice shot! But photos like these don't always go along with my other work, so...

▮ V: I'm a huge Egypt fan, so...

■ CG: I've been there three times. I've enjoyed it. But once again, it depends on what you do and who you know. I used to change money there and... you go down into the *souk* and you talk to the right person and in five minutes you can double your money.

I'm glad I experienced all those lonely nights in dangerous situations—it made me a stronger person! But how can we slow down time—do something we don't like?!? I don't think so...

Charles Henri Ford

Early years of travel

■ V: How did you learn Swedish?

■ CG: I worked two Norwegian freighters to get to Sweden, so I had to learn some Norwegian in order to work, and Swedish is very similar to Norwegian. At the Vinergrand School for English-Speaking Students I took classes in Swedish the two school years I lived there—after two months I dropped out of the sociology classes because I didn't find them interesting, but I *stayed* in the Swedish classes. I became *almost* fluent; I could read a newspaper, read a book, follow a conversation... and I haven't spoken it since! I had planned to *stay* in Sweden, so I thought, "May as well learn the language."

■ V: Let's do a timeline—

■ CG: In the summer of 1964 I got to Europe and traveled; then from Sept '64 to May '65 I spent the school year in Sweden.

■ V: Then you traveled Europe again and returned to Sweden for the school year from Sept '65 through May 1966. Where'd you live?

■ CG: When I first got to Stockholm, Sweden, I rented a room from a widow in central Stock-

holm; I could walk to the school. Nearby there were these "workers' restaurants" (for taxi drivers, mechanics, people in the *neighborhood*) where you could get a big plate of meat-and-potatoes-type food for sixty or seventy cents.

▮ V: Then in summer of 1965 you went traveling in Europe—

■ CG: I went to visit my friend Xina in Paris. She was the "rich girl" in New York whose father had made one phone call and gotten me a job on the Norwegian ship. I had kept in touch with her by letters (filled with clippings and pictures, with funny stamps—I do some Mail Art) and postcards. I don't remember ever making a phone call back then; it was very expensive and I never had any money.

▮ V: How did you get from Stockholm to Paris?

■ CG: I hitchhiked; it was only a couple days! It takes four days to hitchhike to Turkey. **I've hitchhiked enough miles to go around the world! In Northern Sweden and Lapland there were no cars; you could wait eight hours for a ride.** Sometimes you get lucky and get some *long* rides. Hitchhiking in zero degrees—that was rough.

In Paris Xina and I drove to Grenoble, a university town. We picked up some other people there and started driving toward Turkey. We hit

CHARLES GATEWOOD

Luis Buñuel

Herb Gold, San Francisco 2004

the French Riviera (French people are probably the rudest people in the world), Italy (went to Venice, Vicenza, Perugia, Pisa—Northern Italy; never went to Rome). Yugoslavia is just gorgeous beaches and a lot of beautiful old buildings; you could follow the coastline. And it was cheap! In Dubrovnik, I took a nice photo of a girl playing a flute in a circle.

My photos from these travels were put in my book, *People In Focus,* published by Amphoto. It had chapters on how to take better portraits; how to take better "candids", do better on location... It's a kind of "how-to" instruction manual.

Then we went to Greece, which was fantastic. We went to a little town in the mountains, Delphi, where all the classical stories of antiquity took place; it was the "home of the gods." I went to a lot of sacred sites like the Palace of Minos at Cnossus.

In Spain I went to Altamira to see the cave paintings.

We also went to Turkey. We slept in cheap hotels; for example in Greece and Turkey you could get a room for two dollars a night. We also slept in the woods; we just laid out our sleeping bags. *Europe On Five Dollars A Day* was our *bible*; in each country it told you where

Lawrence Ferlinghetti

to go and what to do. We went to museums and visited ruins; we stayed two days at a villa on Lake Cuomo. I liked Turkey so much I visited it several times; in '66 I hitchhiked to Turkey and spent several weeks doing a feature with John Willett, on Turkish towns...

■ ■ ■ ■

In Charles Gatewood's Words

SAN FRANCISCO

V. Vale, a friend since 1977, hosted me when I was in San Francisco. Vale is a true underground anthropologist; he discovers scenes the mainstream has missed or disparaged, and brings back detailed reports that redefine "cutting-edge." Vale liked the authenticity of my black-and-white photographs and the raw energy of my Body Art videos. I admired his brash Punk tabloid *Search and Destroy,* his brilliant RE/Search books, and his fierce dedication to *accurately* recording Underground Culture.

When I showed Vale my new photos of tribal tattooing, body piercings, branding, scarifica-

V.Vale

tion, and flesh-hook suspensions, he put them into *Modern Primitives* [1989]. Body Modification and New Tribalism now ruled in San Francisco, and what a thrill it was to be part of the movement.

Dances Sacred and Profane, a documentary about me, was a big cult attraction. Its screening at the Roxie Theatre drew a large crowd of RE/Search fans and S&M leather types. There were lines around the block, and the shows sold out.

After the screening, Vale told me my tan slacks and sport coat made me look *way too straight.* "You must get some black clothes," he advised. "Seriously."

That night I met Mark Pauline, founder of Survival Research Labs. Mark was a charming artist/prankster who liked explosions. His violent Machine Art reminded me a lot of Jean Tinguely's rusty-metal sculptures.

In Vale's North Beach flat, I met Jello Biafra, the Dead Kennedys founder, who told me about his run for San Francisco mayor. Jello's platform was radical—no cars were to be allowed within city limits, for example. Jello Biafra came in fourth in the mayoral race, with over 30,000 votes.

Monte Cazazza was another wild perfor-

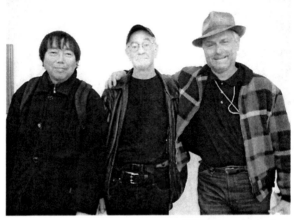

RE A RE/Search Pocketbook

with V. Vale and John Law

mance artist whose actions had been described as "outbreaks of insanity, disguised as art." Monte was kicked out of art school when [allegedly] he had a truckload of wet cement dumped at the school's entrance stairs, blocking it. Later, at an art conference, Monte [allegedly] burned a maggot-infested cat and sprinkled arsenic powder on the buffet food...

■■

"You can stay as long as you like," Vale told me. Except the problem was that his roommate

had other ideas. One day, she gave me the evil eye: "Oh, are *you* still here?"

"Call Mark McCloud," said Vale. "Mark loves hosting visiting artists. He has a big Victorian house in the Mission. You'll have an fascinating place to stay, and you'll meet a whole new crowd of people."

A whole new crowd indeed! Vale hated drugs—McCloud adored them. Mark was a smart, handsome rogue who dressed in bright psychedelic colors. His favorite drugs were tobacco, LSD, and green-bud marijuana. Like Vale, McCloud was a generous host; his kind heart and spirit overwhelmed me. Mark's house didn't look so good from the street; the paint was peeling, one rusty gutter hung down, and some neighborhood kid had tagged the front steps with graffiti. There were "Pot Power" stickers on the window and scars on the wooden door where Drug Enforcement Agents (DEA) had smashed it during Mark's last drug arrest.

Contrasting with the interior, the interior of Mark McCloud's house was decorated like a beautiful Tibetan temple. The red and purple walls were hung with psychedelic art, including an oil painting by Alex Grey. **Hundreds of examples of LSD Blotter Art hung on other**

walls. Psychedelic history was writ small in those blotter squares. Some frames held whole sheets of LSD designs, while smaller ones held blocks of four, called "four-ways". A few tiny frames held precious single squares. "I call it my 'Institute of Illegal Images'," said Mark.

At the kitchen table, I found three girls drawing in coloring books and listening to the Jimi Hendrix song, "Purple Haze." Mark introduced me as his new "artist-in-residence" before showing me my upstairs room. A dozen empty picture frames were stacked in one corner, and thrift-store paintings hung on one peeling wall. Mark said that the fetish photographer Richard Kern had detoxed from heroin in this room while reading my novel *Hellfire*.

Downstairs, Mark showed me more of his museum. He pointed to a beautifully-framed four-way design showing chemist Albert Hofmann taking his famous 1943 bicycle ride while high on LSD. Mark said Hofmann called LSD his "problem child". I told Mark I'd dropped my first blotter acid in Stockholm, Sweden, Spring of '66. Mark looked fascinated: "Where'd you get it? Was it pure? Were there pictures on it?"

"No pictures. Just blotter. It was pure, and each square was super strong. My friend in Zurich sent me a sheet with twenty hand-ruled

blotter squares. Those were my first acid trips."

Mark gestured to his psychedelic walls: "This is the world's largest collection of Blotter Acid Art. My collection spans four decades."

"Have these sheets been dipped?"

"Who knows? We might have to eat some to find out," Mark said with a smile on his face.

I recognized the classic designs—Orange Sunshine, Flying Saucer, Mister Bill, Mickey Mouse, Alice in Wonderland. Other designs, like Snoopy, Dancing Test Tubes, Batman, and Felix the Cat were new to me. Also **on the wall was an "LSD" California license plate**, and next to it hung a pair of ragged men's underwear. "A chemist used these to clean up an LSD spill. After that, they were passed around—hence the expression, 'Eat my shorts'."

I pointed to a Bible, mounted in a red velvet frame. "The psalms," said Mark, "are *electric.* When Tim Leary went to jail, his friends sent him this Bible. Every time Tim ate a psalm, he found heaven in his mind."

Mark pointed to a framed baseball card. "This is Doc Ellis, who pitched for the Pittsburgh Pirates. **Once, in May 1970, Doc Ellis had a day off. So he dropped some LSD. Then he was called to pitch, and he pitched a perfect game.** He said every strike he threw

had a flaming tail, like a comet. And check out his name—Ellis, D. Is that great, or what?"

I pointed to a framed photo of an official-looking man: "What about him?" "That's Ellis D. Cox. He was San Francisco Health Director during the Summer of Love."

"Now you're putting me on."

Mark handed me a book, *Haight-Ashbury: A History,* by Charles Perry. "Look it up," he said.

Suddenly a six-foot woman rushed in. Tornado was a leggy ex-showgirl who lived in the room next to mine. I found her energy intense and a little scary. She worked at a leather store downtown and said she could get me a beautiful black lambskin jacket wholesale. We became fast friends.

When our conversation turned to Bohemian culture, Mark dragged out his show-and-tell collectibles—what an amazing archive! With his intelligence, warmth, and charm, Mark McCloud was the ultimate gentleman-outlaw.

At McCloud's, everything happened *in the moment*. I met quirky individuals who dropped by to see Mark's weird art collection. I listened one afternoon as a Berkeley professor discussed Bob Dylan song lyrics with an ex-con who'd done hard time at San Quentin. Mc-

Cloud's salons crossed all lines and categories. There were sidewalk poets, graffiti artists, disc jockeys, anarchist poets, wild-eyed painters—all were welcome.

I wanted to shoot some video with my new Sony camcorder, so Mark took me to a Tragic Mulatto show. I videoed a naked girl playing the tuba with her crotch [?!] while guitarist Alistair, who later played for Polkacide and Three Day Stubble, pranced around with a red sock covering his genitals. What a show!

When I asked McCloud to recommend San Francisco's best tattooist, he sent me to Erno's Lower Haight/Fillmore shop. **I liked Erno and loved the bold tribal tattoos of Greg Kulz, his chief tattooist. Kulz was a San Francisco Art Institute graduate who had had big black bones tattooed up and down the length of his spine.** He also had a "bio-mechanoid" design inked on one arm, and another tattoo that moved when he made a fist.

Punks, skaters, and skinheads hung out in Erno's shop along with a few Haight Street "Punkettes." I talked with Babe, who had spiky pink hair, a double-pierced nose, and titanium "nipple shields." As I photographed the rattle-snake tattooed on her left breast, I told her how ten weeks in San Francisco had opened

my eyes. Babe grinned: "I just made some pot brownies. You want to come over to my place and eat some?"

One day Tornado and I sat at Hunt's Donuts, an open-all-night hangout on Mission Street at 20th Street. We ate sugar-glazed pastries and eyed bizarre street people. "Mark calls this 'Donut University,'" said Tornado. "You walk into this place stoned on acid, and you get a *higher* education."

██

HURRICANE HAZE

I returned to Woodstock where everything was wet, cold and depressing. Winter was over, but the endless spring rains tried my patience. Once again, I was alone in the woods. I missed my new friends in sunny San Francisco.

My spirits soared when Patsy called from Minneapolis. I told her about my San Francisco vacation and the rest of my trip—after spending three months in San Francisco, I had flown to New Orleans where I videoed the wild-and-crazy Mardi Gras.

I told Patsy how I had videoed "Bike Week"

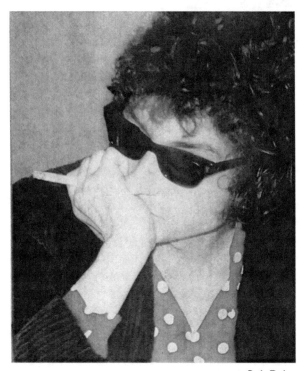

Bob Dylan

in Daytona Beach. After the outlaw bikers roared away, the Spring Break kids arrived— imagine 300,000 crazed college students in full party mode! I videoed wet T-shirt contests, took funny photos, and conducted on-the-

beach interviews. "You want to know the sad part?" I asked.

"What?"

"The cigarette companies were there, handing out free samples. Budweiser had a hospitality tent offering the kids cheap beer and free phone calls. Get 'em young, hook 'em for life. It was so depressing. They're such beautiful kids."

"That is a bummer," said Pat. "Hey, can I come visit you in Woodstock? I'm bringing my friend Haze who lives in Minneapolis."

The two girls arrived on Good Friday. I made a pot of English Breakfast Tea and described Mark McCloud's LSD Museum and the wild pranksters at Vale's RE/Search office. Then I said I was leaving Woodstock and moving to San Francisco.

"You're crazy," said Pat. "You've got every artist's dream: a loft in Manhattan and a house in Woodstock. You're nuts. You can't leave."

"Just watch me," I said.

Saturday's weather was wet and cool. Pat, Haze, and I dined at a Saugerties cafe, and afterward watched Wim Wenders' *Wings of Desire* at a Kingston theater. The dreamlike film, a lyrical poem, explored one of my favorite subjects: obsessive love.

On Easter Sunday, the weather was sunny and warm. We sat on my deck, eating oat bran muffins and drinking Earl Grey tea. When Pat said it was time to leave, Haze said, "I'm staying with Charles." I looked into her pale blue eyes: "I'm spending the summer in Amsterdam, and teaching a workshop in the South of France. Would you like to come?"

Haze's eyes got big. Then when Pat had slammed the door, she told me about her list: "I've listed all different kinds of f*cks." Haze opened a spiral notebook. "Listen to this—love f*cks, mercy f*cks, second-choice f*cks, beer-goggle f*cks, blind-ambition f*cks, break-up f*cks, revenge f*cks, quickie f*cks, back-alley f*cks, wham-bam-thank-you-ma'am f*cks, zipless f*cks, propinquity f*cks, tropical-heat f*cks, mile-high f*cks, sick f*cks, lazy f*cks, Mongolian cluster f*cks, and Reddi-Whip f*cks. Do you know other kinds?"

Haze and I went to Minneapolis, where I spent all day cleaning and straightening her messy apartment while she went to an appointment. When Haze returned she said, "Wow, thanks a lot for cleaning." Then we sped away in her Ford, with her boom box blasting reggae beats. In Dinkytown—the artsy bohemian neighborhood—we watched a band of ragged

Punks face a squad of riot police. Red lights flashed, police radios crackled. The atmosphere was tense and dangerous.

"This is our Punk scene," said Haze. "Last week, Punks stoned the police and set a Jeep on fire. They really like causing trouble." We got out of there while we could.

The next day, a fresh-baked carrot cake balanced on my lap as we drove to Haze's family reunion. When we arrived, the food table was covered with hot-dish casseroles. Several dishes were made from Campbell's tomato soup, Velveeta cheese, and Kraft elbow macaroni. There were platters of pan-fried chicken, a meatloaf with olives, a tray of foot-long hot dogs. For drinks, there were tubs of cold soda and pitchers of sweet iced tea. Haze pointed to the jumbo coffee urn: "We call coffee 'the Lutheran drug of choice.'"

I spoke rusty Swedish with white-haired Uncle John, who was thrilled to hear I'd lived two years in Stockholm. Meanwhile, Haze's mom jabbered on about visiting five different candy stores looking for the "right" jellybeans. Haze's dad wore gold-rimmed bifocals and a checked tweed jacket. His breath smelled like coffee and cigarettes: "I hear you did a book with William Burroughs."

"Yes, indeed. It's called *Sidetripping*. Would you like a copy?"

"I'd love a copy." He leaned close. "I read *Naked Lunch*. That was one *strange* book."

"Dad's a closet beatnik," said Haze. "When he was young, he used to go on hitchhiking trips. Grandma would drive him to the highway, and stay to see he got a ride. Dad's a secret rebel. He sneaks cigarettes when Mom's not looking." Dad turned beet-red.

∎∎

The next morning, we flew to New York. It was late afternoon when our taxi reached my friend Biggs' Manhattan squat. His apartment smelled like pot smoke, incense, and rice pilaf. Biggs gave us clean towels, and showed us how to pull out the found-on-the-street sofa bed.

The next day we flew Air Jordan to Amsterdam. Then came the dollar shock: a no-star hotel cost 120 guilders (65 dollars) a night. (In the Sixties I had stayed in budget European hotels for three dollars a night, which had included a big breakfast.) We looked for a cheap hotel until finally we stood in the lobby of a dingy guesthouse. An unshaven man glanced up from his television: "We have a room in the attic for

80 guilders."

"Can we see the room?"

"Sure, top floor."

"We'll take it," I said. Haze gave me a dirty look.

It was, without a doubt, the worst room in Amsterdam. There were muddy footprints on the floor and cigar butts in the ashtray. A ragged chintz bedspread covered the swayback bed. The wallpaper was a faded floral pattern. A pine table was covered with graffiti and burned by cigarettes. From the ceiling hung a frayed electrical wire holding an empty socket. "We'll find a better hotel tomorrow," I said. "Right now, let's get something to eat."

We ate a forty-dollar lunch at a sidewalk cafe near Central Station. Afterward, I gave Haze a walking tour of the Red Light District.

Next morning my jet-lagged mind floated back to consciousness. Far below, I heard muffled street noises and sounds of distant traffic. Somewhere, church bells were ringing. I opened my eyes and peeked out the filthy window. Bright morning light cut patterns on the red tile roofs below. When I opened the window, I smelled fresh-baked bread. Haze opened her eyes: "Coffee," she moaned.

Again, Amsterdam's prices were scary. Our

Jack Micheline

breakfast of six coffees and four pastries cost $28, plus tip. On our way to the tattoo artist Hanky Panky's, we saw pretty bikini-clad girls smiling from red-light district windows. We found Hanky Panky tattooing a unicorn on the breast of a young woman. "Hallo, Charles," he said. "Welcome to Holland. You want to photograph this beautiful Dutch girl?" After I took photos, he taped a sterile bandage over the girl's fresh tattoo. "Keep it dry," he said. "Don't pick or scratch it." Then Hank presented me with an Amsterdam Tattoo Foundation certificate.

"Suppose I contribute some photographs to your tattoo museum?"

Paul Krassner

"Done," said Hank, filling out my certificate. "Send me some good photos."

"Hey," I said, "we need a place to stay. You know of anything?"

"We have a small room upstairs," said Hank, "but there's no running water. Why don't you call my friend Yolanda? She's got a nice squat, about twenty minutes from here. Yolanda has wanted to take a holiday in Spain, so it might work out. Here's her phone number."

We found Yolanda's squat at the end of a treeless brick street. The steps to her third-floor apartment were even steeper than those at our no-star hotel. Yolanda was an attractive redhead in her early thirties, who said: "How long would you like to stay?"

"Six weeks," I responded.

"How about 1500 guilders? That includes phone, electric, and cable TV. What do you think?"

We looked around. It was a one-bedroom apartment furnished with ratty furniture. A tiny black-and-white television rested on a plastic milk crate. Thrift store oil paintings decorated the walls. The toilet had no seat. The shower dripped. The kitchen was impossibly small. Even so, it was a big improvement over our no-star hotel.

"How about 1000 guilders?"

"Well, all right," sighed Yolanda. "Can I have the money now?" I signed several traveler's checks, and we left...

Six weeks later Haze and took the train to Paris and then took a taxi to the Left Bank. I sat on a park bench while Haze went to find a budget hotel. She came rushing back: "I got us a nice room for only 200 francs. And guess what? Shakespeare and Company bookstore is just a block away. They have Allen Ginsberg's latest poetry book in the window!"

The next day we took the train to my teaching job in Arles. Our three-star room at the Hotel Arletan was furnished with lovely antiques in the French Provincial style. There was pink primrose wallpaper, a crystal chandelier, and a luxurious bathroom with a porcelain bidet, claw-foot bathtub, and elegantly wrapped bars of lavender soap on the marble washstand.

At the Place du Forum, I heard a shout, "Hey, Charlie!" It was Freddy Vogel, an international photo agent with some very big-name clients. (Allegedly Freddie had a drinking problem, and sometimes he "lost" valuable prints, like the Edward Weston portfolio he "left in a taxi." Everyone suspected Freddie had a secret photo trove stashed somewhere, but no one knew for

sure. However, Freddie seemed to know *everyone*.) He flipped his Vuarnet sunglasses on top of his head and flashed his piano-key grin: "The power table's over here, Charlie. Come on."

I said hello to Ben Fernandez from Parsons School of Design, who had nominated me for the Leica Medal of Honor. Helen Marcus, director of the American Society of Magazine Photographers, waved hello and smiled. Jeff Dumas, publisher of glossy photo books, said howdy. Next to him was Will McBride, a photographer who had published a book titled *Show Me*. Next to Will McBride sat Allan Porter, editor and publisher of *Camera*, the world's finest photography magazine.

Right on cue, Freddie Vogel said, "Hey Charles! What's new?"

I showed everyone my books: *Sidetripping, Wall Street,* and *Forbidden Photographs*. Quickly I was invited to a pool party at the Maine Photography Workshop's villa, to an Institute of Art photo shoot, and asked to submit a portfolio of black-and-white nudes to publisher Jeff Dumas. Best of all, Allan Porter invited me to visit his penthouse suite in the Grand Hotel. "Come at noon tomorrow," he said. "Bring your books and prints. We'll talk."

I met Allan Porter in his luxurious pent-

house suite. He wore a red silk robe and fancy embroidered slippers. His deluxe suite offered an incredible view of Arles. A blonde in a bikini was sipping Perrier while watching MTV with the sound off. Her name was Skyler and she was half Swedish, half Thai.

"Skyler is my favorite model," said Allan Porter. "My inspiration. My friend. My muse." He opened a portfolio case and showed me large prints of Skyler naked in the surf. He showed me more prints, all of beautiful naked girls. He was a talented photographer, and his models were world-class.

"I'm known as a *publisher,*" he said. "But I am also a photographer. Art photography is my passion." I looked at even more master prints. There were beautiful nude models posing in formal gardens of big estates. Other supermodels soaked in baths of ritzy hotels and took sunbaths on the decks of luxury sailboats. Allan Porter cruised the world, staying in five-star hotels and taking nude photos—what a charmed life.

Allan told me about his adventures with Kerouac, Ginsberg, and Robert Frank. I told him about my college days, when *Camera* magazine was too expensive for my starving-student budget. Now, here I stood in his luxurious pent-

house. I couldn't believe it when he offered to publish a deluxe monograph of my work.

"*Camera* is finished," he said. "Now we have 'Paris Editions.' We're looking for exciting contemporary photography, like your *Wall Street* photo-essay. We're raising the money now. We'll publish our first book soon."

So, I had a book deal—but no money? At that moment, I caught the first faint but unmistakable whiff of photo-festival smoke-and-mirrors. Yet… maybe Allen Porter actually *would* publish a book of my work. Meanwhile, he gave me the names of several important collectors, and also invited me to a V.I.P. party at the estate of Albert Hofmann, the eccentric scientist who had discovered LSD.

I told Allan I'd taken LSD several times. He smiled knowingly. "I've tried it too," he said. "But I prefer marijuana."

Allan Porter, the wealthy publisher and *bon vivant*, was my new hero.

■■

I stepped out into a noisy street parade. Old ladies in traditional costumes danced by with geezers in broad-brimmed hats. One woman, in a long skirt and bonnet, looked like she'd

stepped out of a Manet painting. After snapping a few photos, I walked the cobblestone streets back to our room.

I told Haze about the festive costume parade, and how Allan Porter might publish my next book. I said Allan Porter had the most outrageous lifestyle I'd ever seen. "He's rich," said Haze. "Rich people use OPM—that means *Other Peoples' Money*. My dad taught me that: Smart people use OPM."

At Place du Forum, I spotted photographer Larry Fink. We were long-time pals, but I hadn't seen much of Larry since he'd married artist Joan Snyder and moved to a farmhouse in rural Pennsylvania. "You look great," said Larry. "Your eyes are clear." **I said hello to photographer Mary Ellen Mark, and greeted Arnold Newman, master of the environmental portrait.** The Director of the *Bibliotheque Nationale* looked at my work, and festival organizer **Lucien Clergue kissed my cheeks and thanked me for coming**.

I waved howdy to photographer Ralph Gibson. Ralph's work was ice-cold and rather formulaic (plus he had a monster ego). I nudged Haze: "See that guy? He's the biggest sex-hound in art photography."

At a cafe near the school, we met Jean and

Petra, two charming French photo students. They invited us to the Maine Photographic Workshop party. **We hopped into their Renault convertible and roared into the countryside, top down, the wind in our face.** The afternoon sun flashed rhythmically through long rows of sycamore trees—the flicker effect. As we rounded a curve, I saw a field of sunflowers in full bloom, glowing Van Gogh yellow.

At the Maine Photographic Workshop party, V.I.P.s stood drinking and enjoying the lavish buffet. Champagne buckets were filled with white calla lilies, and a string quartet played Bach under a fantasy pavilion. Then the sky darkened and a light rain began to fall. The party got crowded as everyone moved inside. Haze and I sat next to a man from Kodak; beside him sat Jane Atwood, who had just received the International Center of Photography (ICP) "Concerned Photography" fellowship for her black-and-white photos of blind school children. Just then, Cornell Capa, the godfather of humanistic photography and founder of the International Center of Photography, strolled in with his wife Edie.

"Hey, Cornell!" I said.

"Oh, no," said Cornell.

"Why do you say that?"

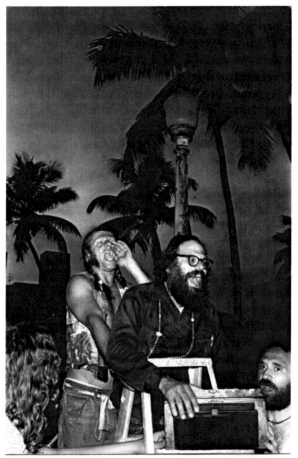

Peter Orlovsky, Allen Ginsberg

Cornell Capa gave me a dirty look: "You are a Messenger from Hell." (I still don't know why he said that…)

My photo workshop seemed to be a big success. The students took many fine pictures. My lecture slides came out perfect. I sold a dozen books, and the school paid me in cash. One of my students, Marie, surprised us all with some evocative, candid shots of neighborhood children.

That evening, photos from *Sidetripping* and *Wall Street* were projected on the big screen in the ancient Roman amphitheater as director Lucien Clergue read highlights of my photographic career. The audience, which was filled with international V.I.P.s, gave me a standing ovation. It was one of the greatest moments of my life.

■■

Back in Amsterdam, Haze and I paused in front of Central Station to watch longhaired backpackers and gutter-punks. They were sitting on the sidewalk, drinking beer from big brown bottles and passing cigar-size joints of hash. A tattooed fire-eater spat an orchid of flame into the slate-gray sky. Another performer, wrapped in rusty chains, yelled and screamed as he rolled in shards of broken glass.

"You want to video?" asked Haze.

"Yes," I said, "but I'm tired. Let's get a taxi."

At our humble squat, we found a postcard from Yolanda. Haze cleaned up the kitchen while I vacuumed. Yolanda had over a hundred albums and tapes, ranging from Miles Davis to Sufi trance music. Her library included books like *Women In Love* and *One Flew Over the Cuckoo's Nest.* But best of all was the cable TV, boasting four Dutch stations, three from England, *Dallas* in German, dancing PopTarts on *MTV*, and a bourgeois newsman speaking haughty Parisian-French.

We settled on a *Rambo* movie. As napalm exploded in a lush green jungle, Haze laughed: "Here we are, watching *Rambo* in an Amsterdam squat. Who would have dreamed it? And coming up are *Dr. Who* and *The Wizard of Oz!*"

Yolanda had told us this was a working-class district where nobody worked. Tough-looking immigrants with pit bulls sat on the steps, smoking cigarettes, drinking beer and scowling. Broken glass littered the pavement in front of graffiti-marked red brick buildings, and there were no trees anywhere.

The next morning I wrote postcards. The first card was to Annie Sprinkle, otherwise known as the "Mother Teresa of Porn." An-

Becky Wilson, S. Clay Wilson

nie had suffered sex worker burnout and now was calling herself "Anya," practicing New Age rites and rituals. I also wrote a card to Marco Vassi, who now lived in Biggs's slummy building. The last time we had talked, Marco had told me about his HIV+ diagnosis: "I tried to hang myself... but the rope broke."

As I walked down the red brick street to mail the postcards, I found a dessert shop with cream-filled pastries, marzipan squares with bright green frosting, and buttery raisin cookies. They also had a display of gourmet chocolate: German chocolate; Dutch milk chocolate with orange bits and almonds, and creamy Swiss chocolate bars filled with raspberry jelly.

After spending an obscene sum of money on sweets, I ran home and listened to Fats Waller playing boogie-woogie piano on the no-knob stereo, while James Bond's *Goldfinger* flickered on the tiny TV screen. I was in heaven.

The door opened, and in rushed Haze. She threw a shopping bag on the bed: "Look—I got combat boots! I got all this other stuff, too—a black fisherman's cap, two black T-shirts, three pairs of hippie earrings, four cheap bracelets, two colored scarves, and several silver rings. I also threw a rock at a Mercedes," said Haze. "I hit it, too. The driver got really mad. He jumped out and chased me. I did it because he whistled and yelled at me."

Haze left to do more shopping while I got ready for an appointment. I displayed my Amsterdam Tattoo Club certificate on the mantle next to a studded slave collar. I dressed in black 501s, a black T-shirt, with a studded bracelet on my wrist. At one o'clock, the doorbell rang. Heavy boots tromped up the steep wooden stairs. I opened the door and there stood the Piercing Doctor with a case of Heineken beer. He was a round-faced man, with intense blue eyes and a shaven head. A small stainless spike pierced the lobe of his left ear.

The Doctor, Hans, was one of Holland's

best-known body piercers. Hanky Panky had told me that **Hans was a medical groupie—an ambulance driver who combined fantasy role-play with a heavy piercing fetish.**

"Hallo Charles," said the Doctor. He set the case of beer on the floor and introduced his friends. "This is Astrid, Oma, and Scutt." Astrid, the doctor's girlfriend, was a blonde with pretty eyes painted Cleopatra style. Her see-through blouse showed large pink nipples, pierced with golden rings, connected by a gold chain. Oma was a mulatto; Scutt, her boyfriend, was a thin, wiry youth—square jaw, spiky hair, and suspicious eyes. I'd heard that Oma and Scutt performed Amsterdam's hottest live sex show and I was hoping to video their act. But Oma looked bored, and Scutt looked angry and annoyed.

"So," I said, "I'm making a video called *Weird Amsterdam.* Would you like to be in it?" Scutt frowned: "How much do you pay?"

"I can't pay anything. But you'll get international exposure, plus many copies—"

"You know," said the Doctor, "we're tired of meeting rip-offs and know-it-alls. And we've *had it* with that Hanky Panky." I smiled bravely as the Doctor vented his anger: Fakir Musafar was a phony, a great pretender. Willem de

Ridder had his nose in the air. Spider Webb was an obnoxious drunk. Fetish Diva Domino had interrupted their dungeon scene without asking, and Mistress Laura Lash had tried to lecture *them* about S&M. Scutt pointed to my Amsterdam Tattoo Club certificate: "This is worthless—how much did you pay for this: five guilders? You should throw it away." Everyone stared at me. Our meeting was not going well.

"Look—I know I'm an outsider. I know this is your scene, and I respect that. I hope you respect my work, too. I'd like you to be in my video. But if you say no, that's also fine."

"For free," said Scutt. "You come here, and ask us—"

I interrupted, "I do what I want. You do what you want. Hanky Panky asked me not to work with you. But I work with whomever I please."

As they were leaving, the Doctor said he *might* appear in my video: "We'll see," he said.

Two days later, the Doctor called: "Astrid and I will appear in your video. Can you come to our place tomorrow at one o'clock?" I hung up and danced around the room: "The Doctor said yes! We did it! Oma and Scutt said no. The Satanist guy said no. I almost got hurt videoing in the Red Light District. But I got the Piercing Doctor!"

We caught a taxi to a suburb of Amsterdam, and found the Doctor's building on a quiet street. The Doctor smiled as we shook hands—but I could tell something was wrong.

"Astrid is sick," he said, "so we won't video today. She got very drunk last night. You should have been here last week," said the Doctor. "I circumcised a famous Belgian wrestler and what a large foreskin he had! Would you like to see it?"

The Doctor held a test tube against the light. A scrap of human skin floated in milky liquid. "Almost four centimeters," said the Doc-

at Viracocha Gallery, S.F.

tor. "Amazing, yes?" Then Astrid joined us: "I showered, and took a pill. I feel better now, and I want to do the video," she said. "Very well," said the Doctor. "Let's go to my laboratory."

The spotless room had formica counters, an autoclave sterilizer, and white metal cabinets filled with needles, ointments, and bandages. The Doctor put on a clean white coat, and Astrid took off her red kimono. She lay face up on the padded leather table. After taking a roll of color photos, I turned on my video camera.

The Doctor removed Astrid's nipple rings. "Astrid likes gold jewelry," he said, "but some girls are allergic to gold. For them, I use surgical-grade stainless steel."

The Doctor painted Astrid's nipple-holes with sticky brown goo. Then he *pretended* to pierce Astrid's already-pierced nipples so I could get good video footage. Astrid squealed with delight as he re-inserted her nipple rings. The Doctor applied more brown goo, and covered each melon breast with a fresh white bandage. "Such a good girl."

My next meeting was with Nat Finkel, a New York photographer who had worked with Andy Warhol. He had a studio near Leidseplein. He had said he would help me shoot some video scenes for *Weird Amsterdam."* It turned

out that Nat Finkel had shaky hands and booze on his breath. He also had a three-chip Sony video camera and a slinky Hungarian girlfriend named Kat. **Nat Finkel was an insider—his documentary photos of Warhol's crowd weren't great art, but they were solid documents of Warhol's life and times.** Joe Dallesandro looked rough-trade hunky; Taylor Mead looked surprised-and-puzzled; Billy Name had trickster eyes; and Viva Superstar looked very stoned.

"How did you meet Andy Warhol?"

Nat lit a cigarette and blew smoke. "I met Andy at the Factory, in the spring of 1967. I was at a swinging party in Greenwich Village. Paul Krassner's wife said, "Hello!" and we clicked. She took me to the Factory, which was one big crazy happening. Billy Name had decorated the walls and ceiling with silver paint, aluminum foil, and bits of broken mirror. I saw Brigid Polk jabbing freaks with a hypodermic, injecting speed right through their clothes. The crowd was a mix of beautiful people and low-life junkies. Anyway, we found a couch and got busy. While we fooled around, someone stole her purse. The Factory was that kind of place."

"Warhol was gay, right?"

"Andy liked boys," said Nat. "That's for

sure. But **Andy hated to be touched**. You know what Andy really loved? He loved his Polaroid camera. He loved his tape recorder. He loved watching beautiful people do dangerous things. Andy was a classic voyeur. He liked taking intimate photos—and he loved to watch."

"What drugs did Andy use?"

"Speed, mostly. Obetrol and Dexamyl, a quarter or half at a time. Andy always had a buzz going. Always."

"What else?"

"**Andy collected celebrity porn.** Some of it was really hot—but I can't reveal the names. Oh, he had a stainless steel plate implanted in his skull—so his wigs wouldn't blow off. How's *that* for body modification?"

Cora rushed in with a box of messy food. Cora was the wife of Fluxus artist Willem de Ridder—a designer and performer, forty years old and gorgeous.

"Okay," said Nat. "Let's get started."

"Can I video?"

"When I'm done,'" said Nat. "Now, let's dress the set."

Nat pulled a plastic sheet over the double bed and taped it down. He adjusted the quartz lights and laid out some food. "Okay, girls, get naked. Charles, give us some privacy, please."

Andy Warhol and Monique Van Vooren, NYC 1975

I stepped outside. The door closed and I heard shouts, squeals, and laughter.

It was almost midnight. I looked at copies of *Artforum* and *Art In America* as I waited. Finally Nat said, "Come in." I stepped into the quartz-light glare. On the plastic-wrap bed sat lovely Cora. She was gloriously naked, and totally smeared with sticky goo. Beside her, streaked with raspberry jam, sat an equally messy Kat.

"Action," said Nat.

Cora covered Kat with a large jar of fruit cocktail. A whipped-cream attack came next, followed by drizzles of chocolate and squirts

of baby oil. Slippery hugs, a sticky spanking, a squishy slide on the food-slick plastic. My video camera caught it all.

Nat killed the lights. "That's a wrap, kids."

Two days later the phone rang. It was Nat Finkel. "Last night's party was *amazing*. It's a whole new trip—warehouse parties called 'Raves.' We were flying on *Ecstasy*, dancing to tribal trance beats, and everyone felt connected. We were one throbbing organism—"

"Sounds like you're still throbbing."

"I'm still seeing wild colors," said Nat. "I just took some speed, and it gave my brain another spin."

■■

It was time to return to New York; the big European adventure was over.

The trouble started at the Schiphol Airport. There was a big terrorist alert, and the Air Jordan terminal was locked down. Security cops with automatic weapons swept the hall with bomb-sniffing dogs. Carry-on bags were checked and re-checked.

When my turn came, the security guard saw the grinning-skull hologram on my Sony video camera. He called out, and other guards

appeared. "Demonstrate the video camera in use," said one official.

"I pointed the camcorder at the official. "Stop! Do not film our security procedures!"

I videoed and played it for the guard. Bomb dogs sniffed my camera bag. Screeners examined my videotapes and rattled my film cans. They made me snap a picture with each of my still cameras. After another pat-down, armed commandos took us aboard the plane. Inside the cabin, women in headscarves shrieked as kids ran amok.

When we landed at JFK, we got a cab driver who drove too fast. His radio blasted out an obnoxious talk show, and when I asked him to turn it down, he ignored me. When I failed to tip him, he yelled at me. Good old New York.

Biggs greeted us through a haze of pot smoke. "Welcome to my humble squat. Want to smoke a bong? I've smoked pot for years, and life is getting better all the time. Guess who's interviewing me? *Yale Alumni Magazine*. It might be a cover story: 'Ph.D Drives Gypsy Cab.' My star is rising. **By the way, pot makes me feel normal**," he laughed.

The next night I went out with a friend nicknamed Frosty the Snowman and ended up at a crowded art opening on West 57th Street,

where I ran into Trish, a photographer I had met at ICP. "My career is going nowhere," said Trish. "Two years out of art school, and I feel *stuck.* I've only had one show—in a Greenwich Village cafe—and I haven't been published at all. I'm just not meeting the right people, you know?" I sympathized, but there was nothing I could do but smile.

Pixie and Patsy, who had rented my Wood-stock home while I was in Europe, showed up at Biggs's apartment. "I brought your mail," said Pixie. To my delight, I found a letter from *Demonia Magazine* offering three thousand dollars for the French rights to my video *Erotic Tattooing and Body Piercing.* "Yippee!" I cried. "We're rich!"

Haze cheered up fast. "Oh boy," she said. "Now we have money for San Francisco. And now you can buy me a corset, a good leather jacket, and a pair of thigh-high boots."

"And you can fix your house," said Pixie. "By the way, Patsy and I would like to keep rent-ing it. How much would you charge us year-round?"

"Six hundred a month."

"Great," said Patsy.

▌▌

BAGHDAD-BY-THE-BAY

Haze and I arrived in San Francisco on Thanksgiving Day. I drove us to Potrero Hill, where my friend Dirk [pseudonym] owns a big Victorian house. Dirk had promised us a big sunny room, but when we arrived there was a surly slacker in our bed. The Gen-X whiner sniffled: "Poor me, I've got a killer cold and no place to- go." So we slept on the couch, exhausted from our long cross-country drive.

Dirk, our host, was a big-name artist who'd won international acclaim for his site-specific installations of monumental metal outdoor sculptures. Major institutions bought his work and he had shows at top galleries around the world. Dirk was also an avant-garde musician, a gourmet cook, a blues-and-soul lover, and a motorcycle-riding rebel. Yet Dirk could stop after one glass of wine, and drugs didn't interest him at all. A visionary artist who didn't abuse alcohol and drugs? He was one in a million.

In San Francisco, I focused on making videos capturing the strangest, most bizarre footage ever filmed. I included scenes so weird that customers saw worlds of kink they never dreamed had existed. The profits started rolling in—it was amazing.

At Mark McCloud's salon, a handsome young man introduced himself. Nick was a publicist who worked with fashion models and various show-biz types. "My hobby is nude photography," he said. "Would you like to see my pictures?"

After I looked at his photos, he said, "I'm spending tomorrow at Zuni Hot Springs. It's a clothing-optional resort in the mountains, near Ukiah. Would you like to join me?" The next morning Nick picked me up in his shiny BMW. His car stereo blasted hip-hop beats as we rolled across the Golden Gate Bridge. Nick said, "**Man was born to hunt. It's part of our genetic code.** Naked girls, gourmet marijuana, hot mineral springs, a beautiful day—what more could we ask?"

At Zuni, Nick showed me around. The Terrace Pool, surrounded by vines and flowers, looked like a Maxfield Parish painting in the dappled light. On the lower level was a bubbling hot pool enclosed by a gazebo hung with sparkling crystals and covered with orange-flowering trumpet vines...

When I returned, Haze had found us an apartment with a sunny office, a brand-new kitchen, and a large living room with a wood-burning fireplace and a panoramic view of

downtown San Francisco. Three large windows gave north light that was perfect for living room photography. In the back, outside the bedroom, a balcony overlooked a tranquil Zen garden. Several kinds of flowers were in bloom, and a small waterfall gurgled into a small fishpond.

We bought a brand-new mattress, a white leather chair, an ultra-suede couch, a 32-inch Sony XBR television... At Community Thrift, we found a Dansk maple table and chairs in near-perfect shape. I felt reborn—I was now living in *San Francisco*...

My business, Flash Video, continued to grow and prosper. I had just nine titles, which was barely enough for a four-page catalog, but my videos—*Weird America, Weird Amsterdam, Weird San Francisco, Weird Spring Break, Weird Bike Week, Erotic Tattooing and Body Piercing, Fangs of Steel, Shaved, Bizarre Fetish*—sold like crazy. Most of my buyers were older men in small towns who wanted the weirdest scenarios imaginable... close-ups of genital piercing, extreme blood sports, erotic needle play, hot wax, messy liquids, and other blasphemies. I sold my videos for $60 each—most of them at full price by direct mail. I also joined an agency that advertised Flash Videos in several adult

magazines. The agency sold me each catalog request for 25 cents, and I sent out the catalogs. Mail-order sales were great, because customers paid full price—and I got their names for my growing buyer's list.

One day Haze came home from work and announced, "I'm pregnant and I've decided to have the baby. Will you marry me?" I frowned and shook my head: "People like us shouldn't have kids."

Haze got so upset her face turned beet red. Soon she got an abortion and then left town.

■ ■

MORPHOS; MUSEUM OF DEATH

San Francisco's hottest alternative art gallery, Morphos, was owned by an ambitious young woman named Catharine Clark. When I heard Morphos Gallery was showing Nina Glaser's edgy photo-nudes, I stopped by to check out the show—it was splendid. The next day I phoned for an appointment.

Catharine Clark was a smart, savvy Ivy League grad, obviously destined for success. Some rare individuals have the power to visualize their whole career when they're still very

young, and Catharine Clark was one of them. I showed her a portfolio of 16"x 20" exhibition prints from *Primitives*. The book had cost a fortune to print ($25,000 for 2000 copies). Catharine liked the photographs and offered me an exhibition of my work.

I showed my photographs twice at Morphos Gallery. My 1992 show drew a crowd and we sold five prints. For my next Morphos show in 1994, I exhibited eight large silk-screens. Making the silk-screens cost a lot of money, but I didn't mind. My growing video company—Flash Productions—paid for everything. I wanted to make a big art-world splash. My opening night was exciting; there were lines around the block and stretch limos double-parked outside.

A week later, Catharine Clark got a call from the Rita Dean Gallery in San Diego: "We want the Gatewood show. Ask Charles to call us right away." The Rita Dean owners, J.D. Hall and his wife Cathee, sounded excited: "Come on down; we love your weird photography. We know you'll like our art gallery."

I loaded the artwork in my Honda, and drove south to San Diego. When I met J.D. and Cathee, I was surprised. San Diego is a conservative town, but J.D. was a tattooed Punk from

Miami, quick and tough, in his mid-twenties. Cathee wore a skin-tight latex dress and red high-heeled shoes. A tiny lizard claw dangled from her stainless nose ring. **The Rita Dean Gallery had featured an LSD Blotter Art show by Mark McCloud, and "Magick Sigil Collages" containing blood, hair, and body fluids by the British artist Genesis P-Orridge.** I told J.D. that I knew Genesis P-Orridge well, because he and his family had lived for a while in Monte Rio, on the Russian River, near my country cottage there. The last time I had visited them, Gen's two daughters had watched *Ren and Stimpy* cartoons while we ate spaghetti and chewed magic mushrooms in the hot tub.

"Great guy, huh?" said J.D.

"Yes and no," I responded. "Genesis is an important artist. He's the godfather of industrial music, founder of Throbbing Gristle and Psychic TV. He's quite brilliant that way. I especially like his rave parties; Genesis gives the *best raves*. But Genesis has a big messiah complex; he thinks he's God."

J.D. showed me the Rita Dean bookstore, containing the world's strangest titles. My favorite book was the heavily-illustrated *Stone Age Surgery*. The underground zines were fascinating, too: *Art Hole, Bad Attitude, Crap*

Hound, Lord Stink, Hamburger Eyes.

J.D.'s basement housed the "Museum of Death," a lurid exhibit of mass-murder memorabilia and atrocity photos. The museum featured a working guillotine, a genuine electric chair, and other shocking displays. Admission cost five dollars, and dozens of tourists visited the museum every day.

J.D. pointed to a glossy photo on the blood-red wall: **"This is a print of Frida Kahlo lying in a pool of blood.** She's covered with gold dust, see? When her bus hit a trolley, a steel rail pierced Frida's body. A banker's briefcase broke open, and Frida was dusted with gold. Isn't that something?"

The Museum Of Death had two clown paintings by John Wayne Gacy, the serial killer who had posed as a clown. Also on display was a baseball signed by Charles Manson, smuggled in and out of jail. I was introduced to Heckel and Jeckel, the Museum's two-headed turtle. I also met Tripod, their three-legged German shepherd, and Corruptus, their 400-pound pig. "Corruptus is one smart pig," said J.D. "We have a bungee-cord lock on the refrigerator, but Corruptus figured it out. Last week, he ate a whole ounce of marijuana and got so stoned he was bumping into things; then he lay under the

kitchen table and snored for three days."

After looking at a jar containing a pickled hand, we took Iggy the Iguana for a walk. **As we walked, we discussed Joel-Peter Witkin's corpse photos...**

Later, in the upstairs gallery I met Lobo, a Pagan who wore a black leather kilt, studded leather vest, and gleaming black boots. Lobo's wife Skye was an Amazon warrior who wore a Fredericks of Hollywood dress, a wide studded belt, and shiny spike-heeled boots. A stainless-steel septum tusk pierced her long Nordic nose, and the lobes of her ears were stretched with half-inch wooden plugs.

Skye led Jasmine, a pretty young submissive, on a plaited leather leash. Jasmine wore a Saran Wrap top and a black vinyl miniskirt. J.D. led us downstairs into the Museum of Death. "Oh, wow!" said Jasmine. "Take a picture of my head in the guillotine!" **Jasmine unwound her top and pretended to inject her arm with Jeffrey Dahmer's rusty hypodermic.** Meanwhile, Sammy the Sadist and his slave girl Anyssa, joined us. Sammy was a muscular man with a three-day beard and hard black eyes; Anyssa wore a leather cat-girl outfit. Sammy teased her face with the glowing tip of his cigarette, and she fearlessly dared him to burn

her cheek. "There's a three-day party coming up in Seattle," said Sammy. "It's called 'Kinky Couples,' and it's totally outrageous. Would you like to come?"

Skye also invited me to visit her sacred whorehouse in Santa Cruz. It was called the Temple of Aphrodite. She said she and her sacred prostitutes loved giving pleasure to "generous" men. I asked Skye if the Temple of Aphrodite was the place where my friend Cedar had pleasured thirty-three men in six action-packed days. "Yes," said Skye. "Our motto is, 'Let there be more pleasure in the world—and let it begin at the Temple of Aphrodite.' We create whole worlds of sexual pleasure *every day*. Come visit us in Santa Cruz!"

Skye's Temple of Aphrodite was an elegant Pagan bordello with private rooms for sex, a public area for exhibitionists, and a toy-filled nursery for adult babies. There was a watersports room for golden shower scenes and messy play. The dungeon was well equipped, and the dressing room had elaborate costumes to fit every fantasy.

Lobo, naked under a black leather apron, stood in the dungeon, folding a pile of fluffy white towels. Lobo was forty years old, but had the body of a man half his age.

Mistress Skye held court in the luxurious living room. Celtic chants played on the stereo as a naked girl served drinks to a pair of smiling male customers. The Sacred Prostitute of the Week was Jasmine whom I had met in San Diego. She stepped out of a session room, hugged her client goodbye, and sat down on the couch beside me.

"This is an amazing place," I said.

"What we do is Sex Magic," said Skye. "**We're pleasure activists**, and we facilitate erotic experiences. **We produce ecstatic states of consciousness. Our goal is to blend sensual pleasure with mystical enlightenment.** We take our clients deep into 'magic space.' Some clients come for the sexual thrill, nothing more. But some men go away *changed,* and that's always exciting for us."

"Let's see," said Skye. "Jasmine's in the Royal Suite, and Cloud's in the Dungeon. Why don't you stay in Miss Kitty's Room?" I was handed a brass key, a fluffy black towel, and a sprig of fresh sage.

Miss Kitty's "Inner Sanctum" room had flat black walls with glossy black trim. Heavy black curtains covered both windows. There was a four-poster bed and each bedpost had eyehooks for rope bondage. Over the bed, a large

oil painting showed Lobo as the exterminating angel, stabbing a knife into his own bloody chest—*yikes!* A single red bulb gave the room a demonic glow. On the near wall hung a white sailor hat, a horse's bit, a French maid's costume, and an assortment of whips, floggers, and riding crops. On a long wooden table sat a teddy bear in a tiny slave-harness, next to dog collars of all sizes and a squeaky-bone chew toy. There were red rubber ball-gags and black cotton ropes. A baby pacifier hung on a chrome chain. In the corner, a child's rocking horse stood ominously. **On the far wall was a shelf of strange books, with titles like *Secrets of Professional Dog Trainers*, *In Defense of Prostitution*, and *Anthology of Autoerotic Fatalities*.** And over the bed was a framed needlepoint message: KNOW THY LIMITS.

■■

At my next stop—Portland, Oregon—Guy Swenson, an important man on the local fine-art photography scene, had booked me a museum workshop. I had twelve eager students and three nude models. I demonstrated how to photograph the models, and sold several books.

That night, I gave a slide lecture to a hun-

dred people at the Portland Museum of Art. I showed *Wall Street* and *Sidetripping*—nothing too controversial. I included a few slides of body-modification, putting the neo-tribal movement in historical context. **I talked about primitivism, vision quests, and cultural diffusion.** The audience, Guy Swenson and a woman named Bree apparently liked it, too—she handed me a folded note and scurried away. (The note was a request to photograph her, including her phone number.) The museum director invited me out for dinner and drinks, and the French cuisine was excellent...

I flew to Seattle to attend the "Kinky Couples" party. A woman named Kay met my plane and drove me to the house of Sammy the Sadist, then to Apollo's place, where I'd be staying.

Apollo was a bisexual leather man in his late forties. After showing me his sex toys and *Star Wars* figurines, we descended the steps to the "Redrum" space behind his six-foot bondage cross. It had to be the world's creepiest room. The yellow walls were slashed with streaks of blood-red paint, while black-light bulbs gave the windowless space a demonic glow...

Sammy the Sadist told me about Raven, the "Witch of Seattle": "You're lucky. Raven and

her partner Hawk will perform a cutting ritual, and Raven will do fan dancing, cutting, and blood play. You can photograph and video all you want. Congratulations."

My shoot with Raven was a little scary. I posed Raven in dappled sunlight, and shot a quick roll of black-and-white film. Afterward, as I switched to video, Raven told me about her and Hawk's heavy S&M relationship: "No limits. No safe words. Just total submission." Raven wore iron manacles on both wrists, and a heavy iron collar around her tattooed neck. "These are welded on for eternity," she said. I got fantastic footage.

"Kinky Couples" was an outrageous three-day party where *photography wasn't allowed*. Bright rays of afternoon sun illuminated the dressed-up participants cavorting on the rolling green lawn. Pagans and perverts in full regalia chatted on the sundeck by the pool. Pony Girls pulled their Masters around the manicured yard in custom-made pony carts. I really missed not having my camera...

Back in San Francisco, I found a message from a girl I'd met named Amazing Grace. I called her at once. "I want to come see you," she said. "I need a vacation. This cop has been

Quentin Crisp

doing surveillance on my house. He sits outside in his unmarked car, eating Big Macs and watching. It's disgusting. I've had to turn away several 'regulars' this week."

"So, you thought of me?"

Grace laughed. "Romantic, isn't it?"

I met Grace at the San Francisco Airport. Her mania frightened me a little—it was too much coffee, she said, plus an extra-speedy mix of meds. **"I'm a bipolar, manic-depressive, cross-addicted bundle of nerves. I also have tiny cerebral seizures.** My doctor calls them 'little brain farts.' "

At my apartment, I showed Grace my video of Raven telling the occult meanings of the tattoos on her bald head. **All of Raven's tattoos—bats, birds, planets, and stars—were symbols of space and flight.** "My body is a tool," said Raven, "with which my Mistress taps the force of the Higher Power."

Raven then became Isabella Nightqueen, one of her darker personalities. A black bridal veil covered her crone chest, and steel claws glistened on her bony fingers. Raven sliced a ripe pomegranate with her ritual dagger, and held half a fruit in each hand. "I welcome the Furies," she said. "As I move in darkness, beyond the veil, I see tears of blood."

Grace watched the video with great interest. "Raven is like a hot air balloon," she said. "Someone has to hold her string, and keep her grounded. Otherwise, she would float away."

I walked three blocks to Artists Television Access (ATA) for the San Francisco Sex Information benefit. The doorman wore a skunk-stripe ponytail and a white jumpsuit decorated with brightly-colored condoms. The projectionist laughed when I told her that some people had fainted while watching my video *Bloodbath*. "Don't worry," she said. "We have a nurse on duty. You can't miss her; she's wearing a red-and-white latex outfit."

Verushka, a well-known East Bay Dominatrix, greeted me. On her leash was Bowser, a paunchy middle-aged man wearing a red rubber dress and a jeweled dog collar. "I know dogs," Verushka said, "and **I train my dogs well. Just look at Bowser here. Bowser used to be a dorky computer nerd in Silly-Con Valley. Now, he's a well-trained mutt.** Sit up and beg, Bowser."

Inside ATA, porn loops flickered on the white plaster walls. A purple-haired Punkette stood on a milk crate, crooning off-key sounds and striking dissonant chords on her electric guitar.

Then I joined Crimson Haze ("Advanced Inflation Play"), Pie Man Mike (1-800-PIES-FLY), and other assorted individuals for a film program called *Peephole Pleasures.*

The first film was a scratchy old newsreel showing Tempest Storm pressing her 48-FFF chest into wet cement on Hollywood Boulevard. Flashbulbs popped, and Hollywood's big-breast enthusiasts went *nuts.* Next was a senior-porn movie: *GUM ME BARE (Oral Adventures Without Any Dentures!).*

A gay man showed *In Search of Prince Albert,* a short film he made about the early days of body-modification. "At that time," he said, "the scene was so small you could put all the world's pierced men in one room." Cheers erupted.

At midnight, I screened my three-minute video, *Bloodbath.* Sure enough, a young man fainted dead away. The latex nurse snapped a popper under his nose, adding a sharp chemical smell to the room's already pungent aroma. As I was packing up to leave, a young tattooed girl introduced herself: "Hi, I'm Lola. I really liked your blood video. I do piercing, cutting, and vampire play. Would you like to photograph me?"

"Absolutely."

∎

READ A F**KING BOOK!

I was at San Francisco's annual Anarchist Book Fair. There were over a hundred tables displaying everything from *What Is Anarchism?* to incendiary rants by Noam Chomsky, Howard Zinn, and Kropotkin. I picked up copies of *Slingshot,* the Bay Area's anarchist newspaper. I got an Earth Liberation Front pamphlet and a free T-shirt showing a dynamite bomb with this message: *Ask Me About My Other Hobby!*

I arranged books on my half of the table: *Sidetripping, Forbidden Photographs, Primitives, Badlands, True Blood, Photography for Perverts.* I added DVDs of *Shaved* and *Messy Girls,* and a selection of my fetish videos like *Submission of Shannon* and *Weird San Francisco.*

On my right sat V. Vale, publisher of essential RE/Search books like *Industrial Culture Handbook, Incredibly Strange Films, Modern Pagans.* Vale showed me a brighter side of Punk: "*Real* Punks live simply, consume sparingly, work for personal liberation and fight for social change." I respected those actions, and I had to admit the Punk motto, "Do It Yourself/Anyone Can Do It" was more important now than ever.

At my left sat Jennifer Joseph, the publisher

Diane diPrima

of Manic D Books. My favorite Manic D titles are *Cottonmouth Kisses* by Clint Catalyst, the *Devil Babe Postcards* by Isabel Samaras, and the *Underground Guide to San Francisco*. She published books by Michelle Tea, Jennifer Blowdryer, and Bucky Sinister.

Elsewhere in the room, Ron Turner looked like a radical Santa Claus as he set up the Last Gasp table. Ron is a savvy, self-made entrepreneur who publishes quality editions of artwork by R. Crumb, Robert Williams, and others. Ron handed me his *Last Gasp Newsletter* which contained a chapter of his in-progress memoir. I read his story of growing up in Fresno so poor "you were considered well-off if your outhouse had two holes instead of one." Here's Ron's description of his neighbor Emmit's shack:

"The yard had no fence and only a couple of trees. Two mangy dogs were tethered to an iron stake in the middle of a dirt patch where grass once grew. His people were too poor to own a hose, so the only water that ground ever saw—besides ten inches in winter—was when they threw out Emmit's bathwater, or the dog tipped over its dish."

Vale watched my table while I wandered around. At Food Not Bombs, I thanked Keith McHenry for his wonderful charity work.

Keith and his friends have served over 50,000 meals to hungry people. Keith has also served over 500 days in jail, and has endured countless beatings by San Francisco police. Charged with two trumped-up felonies, and facing serious jail time, Keith finally had to leave San Francisco. Feeding hungry people is a crime, especially if you do it in front of City Hall. Keith moved to New Mexico, where his work continues. Today, Food Not Bombs has hundreds of chapters, and they feed hungry people all over the world.

At AK Press, I inspected the anarchist publications with their motto: *No Gods, No Masters.* Farther along, I saw other exciting books, like *Psychedelic Shamanism, Confessions of a Super Hacker,* and *An Anarchist Cookbook.* I also found a new Dover edition of Albert Parry's 1933 classic *TATTOO: Secrets of a Strange Art,* for only five dollars. I bought *Bare: The Naked Truth About Stripping* ($3), *Mutants: Genetic Variety and the Human Body* ($2), and *The High Times Reader with William S. Burroughs, Andy Warhol, and Terry Southern* ($5). I also found a brand-new copy of Noam Chomsky's *The Prosperous Few and the Restless Many*—for only a dollar. All essential reading.

Back at my table, I read an essay called, "An-

archy Made Simple" in the AK Press catalog, and was moved by this passage:

"Like all good ideas, **Anarchy is pretty simple—human beings are at their best when they are free of authority, deciding things among themselves rather than being ordered about.** *Some say this is impossible, that without government authority we'd descend into violence, lawlessness, and corruption. But look around: isn't that pretty much what we have now?"*

I admired the Anarchist Book Fair poster by artist Hugh D'Andrade. It showed a cartoon of Momma Cat reading to her Baby Cats: *"From Each According To Ability, To Each According To Need."* The poster, printed with vegetable-based inks on recycled, chlorine-free paper, listed speakers, films, panels, art exhibits, and even bike valet parking. It seemed every radical in San Francisco was wandering the crowded Expo Hall. Some had hand-poked tattoos, pierced lips, dreadlocks, and dogs on leashes. One young woman wore a ripped T-shirt reading F**K YOUR FASCIST BEAUTY STANDARDS.

How does one make money at a free anarchist event? Well, profit is beside the point. One table even offered a bowl of "Free Money"

(nickels and pennies). There was a lot of free "stuff." I took photos of a stylish Punk boy with a wild mohawk hairdo—purple and red, stiffened with Krazy Glue—and blue nautical stars tattooed on his forehead. I watched a totally naked, skinny, 40-something gay exhibitionist carrying his clothes in a shopping bag, just in case. **A young man told me some Punks outside were butchering a road-kill raccoon and preparing to cook the critter: "It could make a great photo."** I visited with underground celebrities like Diamond Dave, Miss KittyWhore, and Fetus de Milo. When I asked one gray-haired Berkeley radical her name, she smiled mysteriously: "I have many names."

Fly, a graphic artist with a very short haircut, said hello. She was in her late twenties and said she lived in Manhattan's East Village.

"You do?" I said. "What street?"

"East Seventh Street."

"What number?"

"216 East Seventh."

"I lived at 224 East Seventh in 1966. My rent was only $52 a month. How much does rent cost now?"

Fly grinned. "It's free. I live in a squat."

Minutes later, a long-haired young man bought three of my photography books. He said

he was "knocked out by my underground reporting." He wanted to talk, so we stepped outside into Golden Gate Park, where Punks sat on ragged blankets, smoking hand-rolled cigarettes and eating sandwiches. We chatted for awhile.

Back at my table, Vale handed me a business card. "This man wants to meet you; he's a big fan of your work."

Bradford Carter, Ph.D.
Williams College
Department of Religion.

A few minutes later, Professor Carter stood at my table. He ran the Williams College lecture program, and "Alternative Culture" was his area of special interest. His next lecture series was "Transgression and Taboo"; **John Waters and Kenneth Anger were already onboard. Would I come to Williams College and give a slide lecture?**

Williams College flew me from San Francisco to John F. Kennedy airport. There, I caught a flight to Albany, where a limousine picked me up. As we arrived in Williamstown, I felt a jolt of culture shock. I'd gone from progressive San Francisco to a conservative college town in Western Massachusetts. I felt that the students—children of establishment magnates—

might not appreciate my bizarre photography. And I was right.

As I entered the lecture hall, some joker pulled the fire alarm. Sirens sounded, and we evacuated the hall as firemen answered the false alarm. An hour later, after the firemen had left, I showed my slides and talked about my forty-year career as "the family photographer of America's erotic underground."

My lecture, while well-intentioned, was an earnest flop. There were about a hundred students in the audience, and they showed no interest whatsoever in my work. Several students walked out when I began showing my *Modern Primitives* photos. More students left when I showed my *True Blood* pictures. After my lecture, there were a few questions, mostly hostile, like "Why are you showing us this?" I didn't sell a single book.

On the plus side, Professor Carter grinned as he gave me my check: "I got you more than we discussed." The check was for $2,500—that's a lot of money for a 90-minute lecture. And it all happened because of a San Francisco event called the Anarchist Book Fair.

At dinner, I tried to explain to the Williams College professors how I'd gone from sitting at my table at America's most radical book fair

to lecturing at one of America's most distinguished colleges. I told the teachers how I had nearly missed this opportunity, because when Professor Carter had stopped by my table at the fair, I had stepped outside. The professors nodded and smiled, but I could tell they didn't totally "appreciate" my presence...

■ ■

News item: The San Francisco 49ers announced today that plans to build a new football stadium at Candlestick Point are dead, and that the team will leave San Francisco for a new state-of-the-art stadium in Santa Clara.
—San Francisco Chronicle

It all started with a magic mushroom.

It was Christmas day, 1996. Alone in my penthouse apartment, I chewed a magic mushroom, finishing with an Oreo cookie as is the San Francisco custom.

I was flying high by the time I had finished a fresh-fruit smoothie. I played Bach unacccompanied cello suites by Yo Yo Ma on the stereo and smiled as the first gentle hallucinations danced into view. Colors were extra-bright, space was extra-deep, and everything I beheld

Ornette Coleman

was magical and alive. Geometric patterns dazzled my eyes, and mysterious faces peeked from patterns in the kitchen linoleum.

I'd tripped on mushrooms several times in Woodstock and at Burning Man. Now I was back in touch with the friendly mushroom glow, the insights, the feeling of total connectedness. I'd been reading Terence McKenna's *Food of the Gods,* about a "psychedelic anthropology" I'd never known in college. McKenna wrote that psychedelic mushrooms had greatly facilitated human evolution by sharpening man's visual acuity and improving his hunting ability. **He also speculated that mushrooms may have stimulated human speech, lead-**

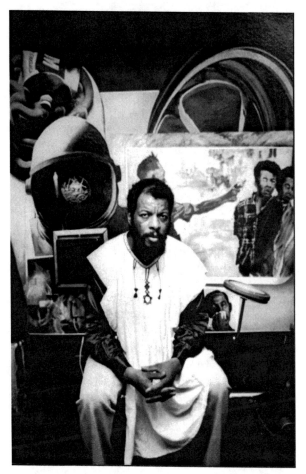

Ornette Coleman

ing to the development of language. In other words, magic mushrooms may have provided the evolutionary leap that made us "human."

Reflecting on my work, I was thinking about how Flash Video, my company, had sold enough copies of my blood videos to make a tidy profit. I had used my profits to make more "unusual fetish videos," and to publish three deluxe hardbound books of my "unusual" documentary photography. But now free access on the Internet was killing my sales; money was tight. What publisher would print my next book? The magic mushroom I was tripping on answered my question: "Go see Ron Turner. Last Gasp will publish *True Blood.*"

Last Gasp—Ron Turner's company—is the world's largest publisher and distributor of subversive literature. Comic art, graphic novels, erotic photography, alternative culture—Last Gasp has it all.

I stopped by Last Gasp's office, only minutes from my apartment. Ron Turner was on the phone, so I admired the treasures in his Museum of Oddities. **Ron has an amazing collection of carnival sideshow banners**, and owns several surreal paintings by the artist Robert Williams. His collection also includes a wall of funhouse mirrors, three antique pinball

machines, and a Winston Smith collage called "Jesus Blessing the Crab Lice."

Before long, Ron was off the phone and eager to see my pictures. We cleared a conference table and I spread out my photos. Ron was fascinated, and not surprisingly, Steven Leyba's Satanic Apache Whiskey Ritual fascinated him the most.

Photo One: A Dominatrix, dressed as Pocahontas, carves a bloody pentagram into Steve's much-abused back.

Photo Two: Evil spirits are invoked as Pocahontas collects Steve's trickster blood in a bowl made from a Tibetan skullcap.

Photo Three: Our Lady of the Perpetual Open Wound spreads her fishnet legs and urinates all over Steve's bloody back.

Photo Four: Pocahontas straps a Jack Daniels whiskey bottle in a dildo harness, bends Steve over, and gives him a whiskey enema.

"Tell me," said Ron Turner. "What's this about?"

"It's Steven Johnson Leyba. I shot these photos at Burning Man."

Ron Turner smiled. A wink, a nod, and *True Blood* had a publisher!

Fast forward to May 1997. *True Blood* was in the final stage of production. Ron Turner was

planning an over-the-top bash to celebrate the 50th birthday of Jack Davis, his bad-boy drinking buddy. Ron was looking for a world-class prank, not some little ha-ha joke, but something big: an *ohmigod* prank.

Well, it just happened that publisher Ron Turner also had a new book to promote, a 64-page shocker called *True Blood,* featuring Steven Johnson Leyba's Satanic Apache ritual in all its glory.

Whoa, you say. Who is Jack Davis, and what does this have to do with the San Francisco 49ers football team? Here's the story on that:

Jack Davis is a certified political heavyweight, a pudgy gay troublemaker usually seen with a cellphone in one hand and a glass of whiskey in the other. His powers and influences in San Francisco politics are legendary. It was Jack Davis who led Willie Brown's mayoral campaign to a landslide victory. Now Jack Davis allegedly had been paid a hundred thousand dollars to lead a campaign promoting a hundred million dollar revenue bond issue to finance a new 49ers football stadium and mall at Candlestick Point.

Jack Davis was controversial—to put it mildly. "He is arrogant, volatile, and vindictive," said the *San Francisco Examiner,* "and

plays to win at any cost." Jack Davis was a self-made "operator" who ran with a pack of "bad boys"—gonzo journalists, erotic cartoonists, and underground publishers.

Now this same bad-boy rat pack was planning a bawdy party to end all bawdy parties. *CELEBRATE HALF A CENTURY OF HEDONISM WITH A NIGHT OF DEBAUCHERY!* said the invitation.

On the evening of May 3, 1997, three hundred V.I.P.s, led by Mayor Willie Brown, gathered in the spacious ballroom atop the Furniture Mart on Market Street. Male and female strippers pranced in the fog of a genuine George Lucas "Star Wars" smoke machine. The oily scent of wax candles mixed with the sweet smells of pot smoke and burning sage sticks. The party had a surreal, anything-goes, freaky film-set feeling.

Booze flowed. Music blared. Whoops and shouts filled the air. By the "Star Wars Cantina" stood Danielle Willis, shivering under a heavy winter coat. She'd allegedly been living in a Walnut Creek recovery house, trying to kick her addiction to heroin. But here she was, as promised, to play her role in Steven Leyba's spectacular ritual.

After Willy Brown's opening welcome, the Green Street Funeral Marching Band played

a mournful version of "Happy Birthday." Steven Johnson Leyba then ran on stage wearing a buckskin loincloth and a four-foot Mescalero Apache devil dancer headdress.

"Death to America!" shouted Steve. "And a curse on the 49ers!"

At the end of the ritual performance, the crowd was stunned. "A waste of good whiskey," sniffed Sheriff Michael Hennessey, heading for the door. "Gross!" said Board of Supervisors president Barbara Kaufman, running for the exit. "I don't believe this," said one shocked V.I.P.

Well, the old press maxim is "If it bleeds, it leads." So naturally, the press went wild. *Raunchy Jack Davis Bash May Taint Stadium Drive,* said the *San Francisco Examiner. The New York Times* ran the story on the front page: *Political Party Goes So Far, Even* San Francisco *is Aghast.*

The scandal also made front-page news in the *Washington Post* and *USA Today.* The "Apache Whiskey Ritual" even became a joke on Saturday Night Live's "Weekend Update."

Geraldo, Rush Limbaugh, and Jerry Springer also chased the story. The Jack Davis scandal had it all: Homosexual perverts! Vampire hookers! Weird satanic rituals! Flesh cutting! Bloodletting! Public urination! And—oops!—a foot-

L to R: Ron Turner, Gatewood, Steven Johnson Leyba, D. Willis

ball team running on a 'family values' agenda seeking voter approval to build a new stadium complex.

Jack Davis put out the word: *Do NOT share your party photos with anyone.* Ron Turner told us to stay cool and *not* to respond to queries from the press. Especially bothersome was KGO-TV's Dan Noyes, a blow-dry-hair reporter who was determined to find photos and video footage of the scandalous event.

Dan Noyes was persistent, I'll say that. Somehow he got my unlisted phone number and started calling, begging for my photos and

footage. "I can get you a thousand bucks up-front," he said, "and more with syndication. How about it?" "Sorry," I said, quoting Mayor Willy Brown. "I wasn't there. I left early." "Well," said Dan Noyes, "Can you tell me who invited Steven Johnson Leyba to perform at the event?" "I don't know," I said. But... maybe I did!?!

██

True Blood was finally published by Last Gasp. The book scared everyone—including me. *Photos like *Hannah Cuts Clint's Back* and *Dharma Shashes Her Own Throat* made blood play look perversely elegant. In the afterword, **psychologist Daniel Lapin compared me to St. Teresa, Dante, and Johann Sebastian Bach: "To transform our demons," wrote Dr. Lapin, "we must dance with them."**
Catharine Clark was unsure about exhibiting my blood photographs. She'd liked the way my edgy art had electrified her Hayes Street gallery crowd. She'd loved the enthusiastic crowd who had mobbed my *Forbidden Photographs* opening two years later. But now Catharine Clark had a fancy downtown gallery with an upscale clientele. I should have offered to show my *Wall Street* work there, instead of... Nevertheless,

Catharine Clark gave me a show.

At my opening, Kat looked gorgeous in her red latex suit ($280 at Stormy Leather). Grace looked fabulous in her black leather corset ($370 from Dark Garden). The time had come for us to make our big appearance at the gallery. It sounds fantastic, right? The acclaimed photographer, dressed head to toe in stylish black, leaves his San Francisco penthouse with a beautiful girl on each arm. This was my third show at Catherine Clark Gallery, my first in her new downtown location. I felt nervous, excited—and very stressed out.

Our big entrance seemingly turned everyone's head. I introduced Kat as "my new assistant," and Amazing Grace as "my personal trainer." My ego swelled as fans—Goths, Punks, and underground notables—showered praise on my blood photographs. The accolades were great—and yet I felt awful inside. I was a mess. A Valencia Street hair salon had screwed up my hair: it wasn't medium-brown (as I'd asked), but an ugly orange. I was also annoyed because Catharine Clark had only hung eleven of twenty framed prints—*where was the rest of my show?* Tornado teased me about my orange hair; Mark McCloud gave me a wink. I chatted with the writer Herb Gold, and signed a

True Blood book for an anorexic girl. When I told the *Bay Guardian* critic I was high on hash and mushrooms when I shot the Burning Man Blood Wedding pictures, he just laughed...

■ ■

BURNING MAN

Amazing Grace was calling, and she was excited. "I've heard great things about the Burning Man festival. Can we go? Will you take me?"

"Well, here's the deal," I said. "I'll take you to Burning Man, and I'll pay all expenses. But, my dear, the Black Rock desert is broiling hot—over a hundred degrees in the shade. There are dust storms that last for days, and the jerks in the next tent will blast bad techno music all night long, *guaranteed.* Burning Man is a real-life ordeal. Are you ready for that?"

"I can take it," said Grace. "What should I bring?"

"Burning Man is strictly non-commercial. You bring what you need—food, water, shelter—and you pack it out when you leave. Everything is shared, and nothing is for sale. I hate to tell you this, my dear—there's no shop-

ping."

"Don't tease me," said Grace. "Take me!"

As we drove toward Reno, I described the early days of Burning Man, when it was a rag-tag gathering with no rules. You could race your car on the alkali flats; you could camp anywhere. You could smoke pot, fire automatic weapons, get drunk—whatever. It was *Mad Max* on magic mushrooms, a bizarre festival held in a landscape so harsh it was called "the worst vacation spot on earth." In the old days, Burners "gobbled alphabet drugs", "shot stuff full of holes", and "blew sh*t up." **Everything was permitted; Anything was possible.**

That "Do-Your-Own-Thing" attitude had changed in 1996, when three Burners were badly hurt when a car returning from a Rave camp smashed into their tent. Also, an alleg-edly drunk man named Michael Fury ran his motorcycle head-on into a speeding car and was killed. Because of these tragedies, Burning Man now had a formal structure complete with rules and regulations.

I knew Grace would find some way to shop— I had never met a girl so eager to buy stuff. Sure enough, as we drove through downtown Reno, Grace squealed with delight: "There's a *thrift store!* You told me to bring white clothes, but

who has white clothes? Let's go buy some."

We hit every thrift store in Reno. It was great fun for a while; I love finding fifty-cent treasures, but my shopping only took ten minutes. Grace's shopping took forever. Grace took her time, and *communed* with each item. I acknowledge that such one-pointed attention is a virtue, and I salute Grace's shopping skills. But Grace was slow as molasses, and she wanted to buy the whole store—with my money. I had to buy her a white wedding dress—how perfect—and hustle her out of ThriftTown.

At a Reno supermarket, I bought food, ice, candles, batteries, sunscreen, and several five-gallon jugs of water. And in the tiny town of Gerlach which has five bars and no churches, we joined other Burners for cheeseburgers, french fries, and frosty root beers.

At Burning Man's main gate, I showed our tickets and drove to a parking zone. As we unloaded, a pink-haired Punkette waved and shouted, "Welcome home!" Next we met a tie-dye-clad Deadhead named Peaches. She sat atop a dusty U-Haul trailer, smoking a spliff of pot and sucking on a longneck beer. **"I've got Ecstasy, mushrooms, cocaine, and pot," she said. "All the major food groups, right?"**

We grabbed our gear and went to find my

friends at Aesthetic Meat Camp. At Sadie's Smut Shack, several sunburned hipsters ate grilled cheese sandwiches and looked at old *Hustler* magazines. "Wow," said Amazing Grace. "This is really trippy."

At Bitchy Witch camp, we found a tribe of Pagan women eating pomegranates and singing Goddess songs. "We're looking for Aesthetic Meat," I said. "Well," said one wrinkled crone, "Walk down Happiness Lane. You'll pass Bubble Wrap camp and Bottom of the Gene Pool collective. Hang a left at Camel-toe Court, and you can't miss the Aesthetic Meat Camp. You'll see a ring of bloody pig heads impaled on wooden stakes. Okay?"

After finding the camp, we set up my green-and-white dome tent and put our sleeping bags and clothes inside. Then Grace opened a bottle of cheap white wine and I smoked a pipe of green bud marijuana. We took an enchanted walk past the bloody pig heads and checked out the rest of the festival.

Phone Pranks camp was blasting tapes of their prank phone calls. Farther along, a prancing mime swallowed a fluorescent tube as a crew of mylar-clad space cadets shook their bodies to the pounding rhythms of garbage-can drums. In the distance a motorized couch

chased a silver fire-mobile across the blue horizon.

As we approached Rumpleforeskin camp, we admired the ten-foot Doggie Diner heads parked outside the Bow-Wow Cafe. "Hey," said Grace. "You told me nothing was for sale." "Well, you can buy coffee, ice, and burgers. But that's it. There are no souvenir T-shirts, no tourist junk, no tacky souvenirs. Got it?"

At Sado-Maso camp we saw the voluptuous Raven in her pink-and black camouflage bikini. Hawk, her husband, opened his diaphanous robe to show an ornate silver penis cuff adorning his member. "We just came from the Black Leather Wings gathering," said Raven. "We haven't been home in weeks. Hawk doesn't want to go home. Hawk wants to stay in magic space. He hates re-entry."

Two topless girls waltzed by, with square *Felix the Cat* badges pinned to their sunburned breasts. "Hi girls," I said. "How about a photo?" *Click.*

At the Majoun Traveler, we ate hashish fudge and chased it with glasses of ice-blue lemonade. Somewhere between Aunt Jemima Effigy and Mime-Free Zone, we saw three adorable Lolitas. They looked like little hookers in short shorts, fishnet stockings, and bright

at Viracocha, S.F.

red lipstick, with big puffy hair. "Oh, wow," said Grace. "Take their picture." "They're too young," I said. "Those girls are jail bait. You want me to get busted?"

We strolled down the Avenue of Straw Sphinxes, past Blue Twinkie camp, past the Mysterious Blinking Lights, smoky red flares marking the trail. Microseconds (or eons) later we arrived at the Perpetual Indulgence Camp.

Farther along, the Stitch-and-Bitch Sewing Circle was serving free shots of cherry-tequila Jello. "Yum," said Grace. "Make mine a dou-

ble."

Outside McSatan's (over 666 Million Souls), **a red-eyed lad displayed what he said were tabs of hallucinogenic toad venom. Ten dollars a tab, he said, or trade for Snickers candybars.** His girlfriend had green hair, tattooed knuckles, and blistered gums from excessive fire eating. The best way to kill the kerosene taste, she said, was to drink many, many quinine gimlets. *Of course.*

Back at Aesthetic Meat camp, I watched a pig-masked Punkette plucking potatoes from a bushel basket. She wore a sash that said MISS BONELESS HAM, *and* she was shooting greased potatoes from a rusty tennis ball machine.

Farther along, we saw "Tim the Torture King" sticking 12-gauge needles in soft spots beneath his triple-pierced tongue. As one needle struggled to exit his throat, the Torture King crouched, and dodged a flying spud.

"Hey!" yelled Tim's near-naked assistant. "We're workin' here!"

At that instant, Miss Boneless Ham blew a loud screech on her plastic kazoo. "Listen up," she said. "The Tinseltown Inferno, in collaboration with the Aesthetic Meat Foundation, will now launch sixteen, count 'em, sixteen cans of

flaming Vienna sausage into the wild blue yonder. Stand back, folks! *Pork in the Hole!"*

The Aesthetic Meat ritual performance for that night was an elaborate Blood Wedding. It happened at two o'clock in the morning, and luckily my Nikon autofocus camera captured some flash photos.

At the Blood Wedding, this is where I had first met Steven Johnson Leyba, a Native American trickster who called himself a "Satanic Indian Priest." Steven was half white, half Mescalero Apache, and his sunburned body showed an elaborate roadmap of deep cutting scars. His whiskey ceremony was intended to symbolize how the white man's poison had screwed up the American Indians. Reverend Leyba said, "We'll perform our ritual in the main circle in just a few minutes. I'm glad you could be here to shoot my performance."

The next morning as Grace and I ate breakfast, I heard the Phone Prank camp broadcasting yet another prankster phone call: *"Have you got Prince Albert in a can? Is he circumcised? How can you tell?"*

On the way to Port-a-Potty village, we watched a group of naked people performing a "pits-and-parts purification ritual" (they were misting each other with spray bottles of Evian).

In the distance a sail-driven shark cruised by in eerie silence, past pavilions hung with gossamer silks blowing in the hot desert wind.

While looking for friends on the Center Camp Bulletin Board, we ran into Simone the Cyber Piss Goddess. Her eyebrows were shaved, and her Venusian fairy makeup shone metallic. As we talked, up zoomed the famous motorized couch. "It turns on a dime," said the goggled driver, "but it has bad brakes. Watch out!"

The western sky darkened dramatically. A gusty wind kicked up, blowing dirt and debris everywhere. Tent flaps flapped and Styrofoam cooler lids blew away as the first raindrops fell. The wind howled, the storm picked up force; suddenly a fierce crack of thunder split the air.

Grace and I ran toward our green dome tent. Once inside, we stripped off our wet clothes and wiped our muddy feet. Grace laughed and said, "Let's eat some magic mushrooms." We chased them down with bites of Oreo cookies. The howling wind puffed and blustered as driving rain splattered the tent. Before long, the rain eased off and the fierce storm was over.

Still naked, we stepped barefoot into the squishy brown mud. **The clouds had partly cleared, and a magnificent double rainbow**

hung over the forty-foot Man. The psilocybin mushrooms were coming on strong now. The white shirt I bought Grace at ThriftTown was now glowing tones of red and purple.

I took color photos of the double rainbow arching high over Burning Man's geometric head. Meanwhile, men and women were slipping and sliding in the slime, squealing, laughing, and smearing mud on each other.

As we slipped and slopped in the muddy ooze, I saw DJ Polywog, one of San Francisco's rave disc jockeys, sitting in the front seat of a 1955 Chevy convertible. "Hi, Charles!" she said. "Want a ride?"

Beside Polywog sat Tornado, the leggy ex-showgirl I knew from Mark McCloud's salons. Tornado was wearing dancing skeleton earrings, a crust of dried mud, and not much else. In the back seat sat LadyBug, a club kid I knew from other events. Her dreads were strung with rags and feathers, and her breasts were painted like technicolored eyeballs. Grace and I climbed in the back seat with LadyBug.

"To the hot springs!" said Tornado. The Chevy convertible did not move. "TO THE HOT SPRINGS!" screamed Tornado.

Polywog laughed, and turned off the ignition. "I'm too stoned to drive. Besides, it's all

muddy out there—we'll get stuck."

"I'll get the weather report," said Tornado. *"This is Plundertown Radio comin' at ya live from Black Rock City, rockin' and sockin' your fevered brains with the best platters and finest chatter. And friends, as your delirious minds ponder these and other cosmic riddles, ask yourself: 'How many hits can I handle?' "*

Tornado found another pirate radio station. *"Be careful, burners,"* said Danger Ranger. *"That mud really sucks. Cars and bicycles should not be driven at this time. Give the desert time to dry."*

Sure enough, as we piled out of the '55 Chevy, we saw a totally stuck Ford, throwing mud as it spun its sinking wheels. So much for our hot springs trip.

Back at Phone Pranks camp, the pranksters invited us to watch a video showing a young couple named "Puss and Boots" getting married at a Reno drive-in church. There was a minor crisis when it was discovered that the bride had eaten her peppermint wedding ring. The best part of the video was when Puss tossed her tumbleweed bouquet to the other Punk girls...

One hundred feet away, Ha-Ha camp had a tank of nitrous oxide. Grace and I filled red balloons with nitrous, sat on a muddy wooden bench, and sucked down the laughing gas. What

silly fun.

A flaming red sunset turned the hills a lovely liver-rose. As the last of the storm clouds blew away, a blaze of stars appeared. After changing into our most festive clothes (thrift store wedding dress for Grace, a striped Moroccan *djellaba* for me), we stepped through the fast-drying muck to share the festival's crowning moment—the Burning of The Man.

As we approached ground zero, we spotted the first "lookie-loo locals." Mobs of locals had come in monster trucks to ogle the naked "hippies" and watch the show. Burning Man's

motto was, "Participants, not spectators." But whole families of local hicks had brought folding chairs and coolers of beer to drink while they watched the fireworks and laughed at the naked "freaks".

Just as obnoxious were the media vultures in their new safari outfits, standing by their Winnebagos delivering soundbites to the masses. "You look fabulous," said one fast-talking reporter to a mud-smeared couple. "Sign here, and initial here." Meanwhile, the redneck crowd of locals was growing restless. "Burn the f*cker!" cried one inebriated hick.

Without warning, fireworks exploded in the desert sky, and skyrockets with fiery red tails shrieked into the black velvet night. Drums pounded mad rhythms, and the drunken crowd became a mob.

A semi-naked goddess named Crimson Rose touched a flame to Burning Man's pine wood toes. We watched a tongue of fire dance up the Man's wooden legs. The flames crept higher, until they reached the Man's sturdy wood thighs. Neon veins began exploding, as more flames nibbled the Big Guy's groin.

The Man's wooden prick exploded, spewing a stream of fiery ejaculate.

Burning Man's ass shot a thunderbolt of fire,

and a flaming pinwheel spun around his heart as rising flames reached his geometric head. The Man's wooden arms, raised now, shot fire as more explosions rocked his burning chest.

Naked dancers pranced in the spark-filled smoke as the crowd cheered and flashed snap-shots. A gang of rowdy drunks began to yank the Man's support wires, chanting, *"Pull him down! Pull him down!"*

The crowd went wild as The Man performed his final dizzy dance. The drunken celebrants jerked and pulled, until the giant wooden effigy took a final drunken lurch and fell face down onto the desert floor.

The Man was down! Long live Burning Man!

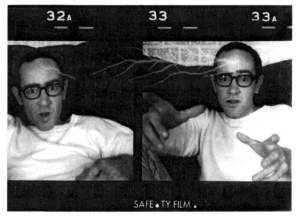

32A 33 33A

SAFE • TY FILM ▲

early self-portrait

Charles Gatewood by Julia Helaine

One of Charles Gatewood's most famous photographs captures a moment even *he* didn't see when he took it: The model, only visible as a silhouette, reclined on a waterbed, and the club-goers surrounding were shrouded in the anonymity of darkness. But when the flash bounced off the ceiling, we saw the woman's white body outstretched, masturbating; the faces of the people watching, mesmerized. **This has been the nature of Gatewood's photography: exposing the people in the dark,**

and people's reactions to them. Throughout his career, Gatewood has portrayed countercultures—capturing the nudists of the sixties, the skin piercers of the seventies, the tattoo artists of the eighties, and the skin-cutting Goths of the nineties. William S. Burroughs said it well: "Charles Gatewood takes what the walker didn't quite see, something in front of his eyes, marginal to his scanning pattern."

Charles Gatewood was born in Elgin, Illinois, a suburb of Chicago, to parents John Jay and Clarene Hall Gatewood on November 8, 1942. His father was a traveling salesman and his mother stayed at home. Gatewood says

Brion Gysin with Dreamachine, his invention, 1972

that his roots are in Texas "farm country." In 1945, the family moved to Rolla, Missouri, and in 1951 to Springfield, Missouri, where he attended J.P. Study Junior High School. Then Gatewood attended a tough inner-city school: "It was 1955, Missouri, a southern state," Gatewood said. "The race relations were tense. Blacks walked to school in groups to avoid beatings from white-trash punks—teenage hoods who wore tight jeans, motorcycle boots, and leather jackets with the collars up. They were constantly combing their hair and calling each other 'Man' and 'Daddy-o.'"

After a divorce, Gatewood's father died in a

fire at a Kansas City hotel. The judge granted half of the father's estate to him and his mother, and along with life insurance money, they received a social security check each month. They immediately moved to a house in a better neighborhood, and Charles attended Parkview, Springfield's best high school.

At age 16 Gatewood bought his first car— a 1950 Mercury, the car James Dean drove in *Rebel Without a Cause:* "The former owner had installed dual tailpipes and 3–2 racing carbs. I removed the chrome, leaded the holes, and had it painted with glossy black lacquer. I added moon hubcaps, new carpets, and a one-arm steering knob. And the ice-pick holes I punched

W. S. Burroughs with eMeter, 1972

Jimmy Page and W.S. Burroughs, NYC 1975

in the mufflers gave my Mercury that throaty glass-pack sound."

In 1960 Gatewood entered the University of Missouri, where he discovered *Playboy* maga-

zine and Jack Kerouac's *On the Road,* finding friends who listened to Miles Davis while they discussed Beat writers. In 1963 he earned his B.A. in anthropology and art history. Importantly, he also met a young photographer named George W. Gardner who inspired him to become a photographer. He saw photography as a kind of anthropology, only *visible.*

Three years later, Gatewood's big break came in Sweden, where he had found a job as a photographic assistant for AB Text & Bilder in Stockholm. Bob Dylan was on a world tour, and Gatewood begged his boss for the Bob Dylan assignment. He photographed the press conference and the concert that night. His skills at the time were not "polished," he later admits—his exposures with black-and-white film had been either too heavy or too thin. "But when I started making prints," he said, "I saw the 'Dylan with cigarette and sunglasses' picture and thought, 'This *might* be a good one!'" The agency syndicated the photo worldwide, and Gatewood "made a few bucks" before his return to the US in 1966, when the US Army sent him his draft card.

In New York City, Gatewood found a cheap apartment in the Lower East Side and worked as a studio assistant—he was still learning the

Jimmy Page and W.S. Burroughs, NYC 1975

photography business. He photographed Allen Ginsberg reading poetry in Tompkins Square Park, and he also had pictures of Joan Baez from when she performed in Stockholm on the Bob Dylan world tour. He sold the three portraits of Ginsberg, Baez and Dylan to a poster company for $105. "A week later," he said, "they were in the windows of every poster shop in Greenwich Village. And **the Dylan-with-a-cigarette poster went on to sell maybe hundreds of thousands of copies. *That's* when I learned to ask for a royalty.**"

The Sixties were in full swing and Gatewood

got invited to a nude party, where he photographed five "hippies" lying on their stomachs on an unmade bed. The *East Village Other* bought the photo for five dollars, and when a poster company wanted it, too, Gatewood had the courage to ask for royalties, which ended up paying a year's rent.

Gatewood had now entered the world of commercial photography, working for publications ranging from *Rolling Stone* to *Businessweek*. He became a staff photographer for *The Manhattan Tribune* by 1969, using a Police Press Pass to shoot politicians and celebrities. Then in 1970 he attended Mardi Gras for the first time with George W. Gardner and shot fifty rolls of film in four days. **He used extreme wide-angle lenses and held the flash low to create demonic portraits**, and compiled these into a dummy for his book *Sidetripping*, but could not find a publisher. Then in 1972, *Rolling Stone* sent writer Robert Palmer to London to interview William S. Burroughs, and Palmer invited Gatewood along to be his photographer.

Burroughs had lived in London since 1965, occupying a modest one-bedroom apartment whose only quirk, Gatewood noted, was a life-size cutout of Mick Jagger standing next to a Uher tape recorder. One might find that

strange considering Burroughs's experimental work with words, images, sounds, drugs, etc., but then again, **Burroughs was known for his philosophy of a kind of double consciousness.** Gatewood said, "Burroughs wore three-piece suits, yet he had one of the most radical minds on the planet." Then Brion Gysin, an old friend of Burroughs, showed up and they talked about the Beat Hotel in Paris, and Burroughs's collaborations with Gysin on dreams and "Third-Mind discoveries."

On the morning of his last day in London, Gatewood showed Burroughs his mock-up for the book *Sidetripping*. Burroughs liked it and agreed to write text, which began: "Step right up for the greatest show on earth. The biologic show. Any being you ever imagined in your wildest and dirtiest dreams is here and yours for a price. The biologic price you understand—money has no value here…"

Back in New York City, Gatewood worked through 1973 and into 1974 as a staff photographer for *Rolling Stone*. **He photographed musicians like Rod Stewart, Dion, Etta James, Sly Stone, Gil Evans, Ornette Coleman and Al Green, coming away with cover-worthy photographs.** He also worked for the *New York Times,* and placed photos with a stock-photo

Brion Gysin and W.S. Burroughs

agency, earning royalties from text-book publishers. He was given a show at the Light Gallery in NYC, and *The New York Times* reviewed the photos as "terribly and beautifully alive."

Over the next two years *Sidetripping* was rejected by over thirty publishers, owing to the strangeness of the content, possible legal problems with text that Burroughs provided (having quoted words from F. Scott Fitzgerald and others), and the fact that photography books were expensive to produce. Finally, Strawberry Hill Books agreed to publish *Sidetripping*.

The same year that he found a publisher, 1974, Gatewood was invited to teach at Cornell University. His class "Photographing People" was a success. *Sidetripping* was printed in 1975, and Gatewood started to become known. His work was exhibited at the Neikrug Gallery in NYC and the Brummels Gallery in Melbourne, Australia, and he won the American Institute of Graphic Arts award. He won a CAPS Fellowship in Photography from the New York State Council of the Arts to photograph *Wall Street,* where he captured the suited businessmen who represented the American economy. The photos show a *film-noir* atmosphere, where men in trenchcoats pass through light and shadow. In one, a businessman flashes an unconvincing

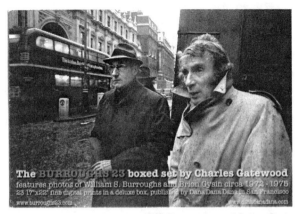

The BURROUGHS 25 boxed set by Charles Gatewood
features photos of William S. Burroughs and Brion Gysin circa 1972 - 1975
25 17"x22" fine digital prints in a deluxe box, published by Dana Dana Dana in San Francisco
www.burroughs25.com www.danadanadana.com

W.S. Burroughs and Brion Gysin

peace sign, and in another, the rails of a turn-
stile reflect prison bars across a business man's
suit. Gatewood said, "**Burroughs's ideas
about conditioning, power, and control
stimulated me.** When I returned to New York,
I began to explore Wall Street as a metaphor, as
neo-fascist architecture, the cold glass-and-steel
environment that said *The World is a Business.*"

Gatewood met Spider Webb, who was infa-
mous for inking people in public when tattoo-
ing was illegal in New York City, and Marco
Vassi, a queer writer. Then he took a road trip
to Minneapolis, Minnesota, where he taught
his "Photographing People" class at Lightwork,

a photography workshop.

Back in New York, Gatewood continued to teach his class at the International Center for Photography, where he met Annie Sprinkle, who was 23 years old and a part-time photography student. Then Gatewood went to Woodstock to teach at the Catskill Center for Photography. **Somewhat daringly, he left Manhattan *mid-career* and bought a house in Woodstock.** His next book was a collaboration: *X-1000,* documenting Spider Webb's project of tattooing a total of one thousand X's on different people. A week after that final X had been tattooed and photographed, Marco Vassi arrived in Woodstock. He was into Gurdjieff, Ouspensky, and Gestalt therapy. Webb moved to Woodstock, too, and opened a tattoo studio on Mill Hill Road. Gatewood filmed Spider Webb interviewing Vassi for a *High Times* article. Over the years, Webb and Vassi contributed to several issues of Gatewood's self-published "zine" titled *Flash.*

Charles Gatewood's next book project, initiated by Spider Webb, was titled *Pushing Ink:* the first book about tattooing as a *fine art.* The two traveled to Los Angeles and began meeting body art pioneers like Cliff Raven and Jim Ward, who published the maga-

Ron Wood and Rod Stewart

zine *Piercing Fans International Quarterly* with Fakir Musafar. In San Francisco, Gatewood photographed Lyle Tuttle's full-body tattoos and Webb interviewed him about his career as "The King of America's Tattoo Renaissance," which *Rolling Stone* had christened him. Tuttle described San Francisco's Summer of Love, how he had tattooed Janis Joplin, Joan Baez, and the period's other stars—he was "at the right place at the right time."

Next, Gatewood and Webb attended a tattoo convention in Reno and a larger festival in Houston. Then they flew to Amsterdam for the International Tattoo Convention. Hank

Schiffmacher (who later became the tattooist Hanky Panky) arranged for them to stay at hostels in the Red Light District. At the festival's opening party, they met tattoo enthusiasts from over thirty countries. Thousands of photographs later, Gatewood decided to publish a new book, *Forbidden Photographs*.

To create *Forbidden Photographs*, Gatewood wrote text about his honky-tonk genes, his father's death, Spider Webb's Hollywood overdose, and Annie Sprinkle at the Hellfire Club, among other biographical moments. He sent the text to his friend "Roger", who set the type in exchange for two signed exhibition prints. After scaling the photos with calculator and ruler, he cut the type into pages and pasted it up with rubber cement. When everything was done, he called a Brooklyn printer, "Irv", who would print the book on 100-pound photo paper for $2,000 and with a hardcover binding for another thousand. A few days after charging $3,000 to his card, the books were printed on Irv's Heidelberg press.

The *Forbidden Photographs* show was held at the Robert Samuel Gallery in Greenwich Village. The gallery had earlier featured the work of Robert Mapplethorpe, Joel-Peter Witkin and Peter Hujar. "When I walked into the gallery, I

saw red dots on several framed prints," Gatewood said. "I thought that ten of my prints had sold! A moment later, Samuel told me it was a sales gimmick." Nevertheless, the party went well. Publisher and photographer Ralph Gibson made an appearance, as did the editor of *High Times,* Larry "Ratso" Sloman. The party continued at the Hellfire Club.

In the spring, Mark and Dan Jury came to Woodstock to film *Dances Profane and Sacred,* a documentary about Gatewood's "underground anthropology." Then the San Francisco Art Institute invited Gatewood to give a lecture, and the Jurys also came to San Francisco, where they met V. Vale who had published some of Gatewood's photography in the Punk tabloid *Search and Destroy* in 1977. Vale was by now the founder/owner of RE/Search Publications). Vale announced his forthcoming book *Modern Primitives*, which would feature many of Gatewood's photographs. It would also include a definitive interview with Fakir Musafar, the face of the "modern primitive"—a businessman/ tattooed, pierced, "inner space" explorer. Gatewood had met Fakir at one of Annie Sprinkle's salons in New York City. The crew visited Fakir at his Palo Alto home. Fakir's motto was, **"It's your body, play with it."**

Larry Clark

Back in New York City, Gatewood had another chance to collaborate with an artist. **Larry Clark, the acclaimed photographer, called Gatewood about writing text for his book *Teenage Lust.*** Clark had liked the text in *Forbidden Photographs* (e.g., "My roots—Ha! A long line of Southern misfits./Whiskey and women. Intoxication. Pleasure. Pain./Ecstasy. Terror. Desire. An overwhelming need to get drunk, to stay stoned..."). Clark and Gatewood's works were similar; both had captured junkies and outsiders up close. Both men had abused the drugs of their subjects, too, but now, after a disappearance and stint in jail for allegedly shooting a man in New Mexico, Clark was sober, and increasingly successful. Gatewood interviewed Clark in Woodstock and at Clark's home, a Tribeca loft with 14-foot ceilings, a maid, and his young fiancee on the phone with a wedding caterer.

Clark said he shot with an M-4 Leica with a fast Noctalux f/1 lens. He never used flash or artificial light, and he never posed his subjects. Gatewood asked his secret to getting intense, "real" photographs. "F/8, and be there," Clark said. He asked Clark about the famous photo of two teenagers kissing naked in the back seat of a car. "I was smashed against the windshield,"

Clark said. "I let this crazy kid drive. Big mistake. The motherf**ker had never driven a car before, and he was going way too fast. We were about to die—but I wanted that shot." "What's your best tech tip?" Gatewood asked. "I overexpose my film, and I overdevelop it. I really like that look. You know my picture in *Tulsa*, the pregnant chick shooting up? You know how her skin glows? Now you know why. I also shoot against the light. It's very dramatic. I learned that trick in art school, actually." "What else have you learned?" **"Stay pure. Ralph Gibson taught me that. I don't do commercial work at all. None. Everything I do is art."** Gatewood finally asked, "So, exactly how rich are you?" Clark told him to turn off the tape recorder—he'd just "ruined" their conversation.

Gatewood transcribed the tape, beginning his text with, "There is something slightly off about Larry Clark's eyes. It's the look of the lunatic in the subway. It's the look in the eyes of Van Gogh, the eyes of an artist whose life has been based on derangement of the senses." After he got the forty-page manuscript, Clark called to say there was nothing in it he could use: what was Charles *taking* when he wrote it?! Gatewood told him. Clark responded that bootleg Quaaludes "mess up a person's head."

■■

The New York Arts Council gave Gatewood money to publish his *Wall Street* book, and he also started writing a novel *Hellfire,* about Manhattan's underground Hellfire Club. Mark Jury called to say that *Dances Sacred and Profane* would premiere at the Antwerp Film Festival, and that Mark's company would fly him to Belgium for that.

Before that trip, Gatewood had taught his "Photographing People" workshop in Daytona Beach. He had also made *Bike Week,* his first documentary video, about Daytona's biker festival. After his Antwerp trip, Gatewood came home to find that Pocket Books had bought his documentary-novel *Hellfire* for $15,000. He bought a big-screen television, a VCR, and a Hi-8 video camera. With the emerging home-video market in mind, he also took video lessons from Woodstock media artist Bart Friedman. **Gatewood planned to make what he called "Underground Videos" and sell them by mail-order.**

Ben Fernandez, chairman of Photography at Parsons School of Design, nominated *Wall Street* for the Leica Medal of Excellence. The judge was Eddie Adams, who won the Pulitzer

Prize for his 1968 photo of the Saigon Police Chief shooting a Vietcong prisoner in the head. "That photograph fueled anti-war sentiment," Gatewood said, "and helped change the course of history. Eddie Adams made a difference. I was floored when he chose *Wall Street* to receive the award." The Leica Medal is one of photography's highest honors.

In New Paltz, a college town south of Woodstock, Gatewood attended a Society for Photographic Education conference. He made over $200 selling his books in one afternoon. Then he went to Mexico for a vacation.

Back in Woodstock, Gatewood accepted a teaching assignment in Chicago, taking a side trip to Minneapolis. Then San Francisco Camerawork gallery offered him a slide lecture; at the same time *Dances Sacred and Profane* screened at the Roxie Theatre, which drew a large crowd. Gatewood stayed with Mark Mc-Cloud, whose home displayed thousands of examples of Blotter Acid Art—a kind of LSD Art Museum. McCloud helped Gatewood get started creating films for his video business, and then Gatewood rented an apartment in San Francisco, launching his second career as a Bay Area Body Art photographer and videographer, where he lives to this day...

■■■■

with Mark McCloud

INDEX

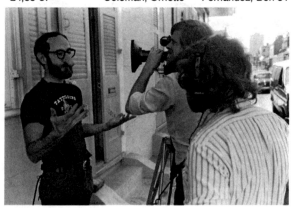

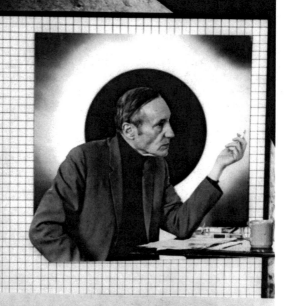

GOODBYE